IMAGES
of America

SEATTLE'S
FLOATING HOMES

Cathy - welcome to my
world.

Matthy.

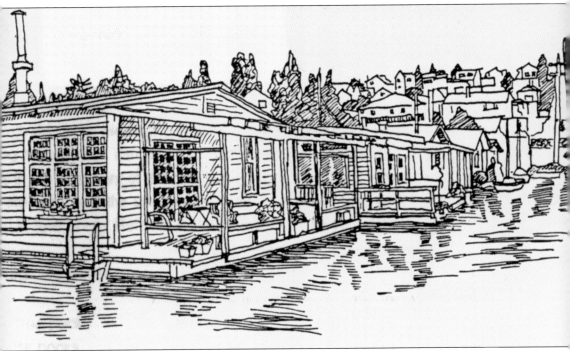

This sketch by Pamela Hidaka, drawn for her 1989 master of architecture thesis at the University of Washington, illustrates how the floating homes are an extension of the surrounding neighborhood along Fairview Avenue in Seattle. In her thesis, Hidaka explored "a design vocabulary for floating home communities," documenting qualities that create the distinct character of floating homes. (Courtesy of Pamela Hidaka.)

ON THE COVER: This photograph shows how a floating home is moved into a moorage by a tugboat. Any houses toward the water from the moorage site must be moved in a "shuffle." Owners and their friends often came along for the ride. This home belonging to Mike Douglas was moved in 1982 to the east side of Lake Union. (Photograph by Stan Clark; courtesy of the Seattle Floating Homes Association.)

IMAGES
of America

SEATTLE'S
FLOATING HOMES

Erin Feeney

ARCADIA
PUBLISHING

Published by Arcadia Publishing
Charleston, South Carolina

Printed in the United States of America

Library of Congress Control Number: 2011943128

For all general information, please contact Arcadia Publishing:
Telephone 843-853-2070
Fax 843-853-0044
E-mail sales@arcadiapublishing.com
For customer service and orders:
Toll-Free 1-888-313-2665

Visit us on the Internet at www.arcadiapublishing.com

*To the community of individuals who have helped the Seattle
floating homes not only survive but also thrive over the years.
This book is an effort to share the complexity and beauty
of all that you have achieved, so that the community may
be valued more than what a price tag can convey.*

CONTENTS

ACKNOWLEDGMENTS

I would like to thank Arcadia Publishing and specifically my editor, Coleen Balent, for her enthusiastic response to my book ideas since day one. Editors Marilyn Robertson, Robby Rudine, and Janet Yoder from the floating homes community and Kathryn Rogers Merlino, professor of architecture at the University of Washington, gave me their constant support and feedback as I worked to complete the book. The board members of the Seattle Floating Homes Association have consistently supported my efforts to research their community, conduct interviews, and collect photographs from residents. Howard Droker's book *Seattle's Unsinkable Houseboats*, published in 1977, provided an incredibly thorough framework from which to begin my research. Finally, I want to thank all of the community residents who have given me their time and trust as they shared their lives with me.

For all image credits, the Seattle Floating Homes Association will be referenced as the FHA.

INTRODUCTION

Living over the water is a long-standing tradition in the Pacific Northwest region, and houseboats have long been part of that tradition. When Seattle houseboats are mentioned, distinct images are likely to come to mind. These might include scenes from the 1993 film *Sleepless in Seattle*, the prospect of owners sipping wine on a dock, or a quaint panorama of little houses floating along the shores of Lake Union. They are not likely to include scenes of families crowded into one room shacks, "floating Hoovervilles" lacking basic plumbing, or late night bootlegging raids, though these all have a place in the long history of Seattle houseboats. The history of this floating community in Seattle parallels the evolution of the city itself, including periods of industrialization, urbanization, environmentalism, and, most recently, gentrification. This book is written to celebrate the unique urban community of floating homes as part of the global phenomenon of houseboats and the vibrant Seattle community.

There are many ways to construct a home suitable for living over the water, including live-aboard boats, house barges, and floating homes. While these are each distinct in construction and mobility, they are all commonly referred to as houseboats. The homes featured in this book are technically called floating homes, which are defined as a house built on a float that is semi-permanently moored to a dock. This term was adopted by the community when the Floating Homes Association was founded in 1962, and it is used in this book for all references on or after that date. Before that date, the term *houseboat* is used to indicate all structures situated for living on the water.

A floating home is a house designed to float on the water with no means of independent mobility, resulting in a connection to land and to a community of other floating homes. What makes them unique is that their over-the-water capability is combined with the comforts of typical city homes, unlike other types of houseboats. More mobile houseboats, including house barges (houses built onto barges) or live-aboard boats (ships that have been converted into homes), are registered as vessels and do not have permanent utilities or plumbing.

Houseboats in Seattle were not regulated by the city until the 1950s, but modern floating homes are required to register at a legal moorage site, meet local building code, and must be connected to a sewer system and other utilities. Building code regulations for floating homes have evolved over the years, and now specific codes have been written to address their height, spacing, and construction. Until the late 1960s—when the trend of cooperative ownership of moorages began—most floating home owners were dependent on the ability to rent a moorage slip on a dock owned by someone else. Although many moorages now own the onshore land to which their dock connects, others lack such stability as their overwater rights are still leased from the Department of Natural Resources or other entities. Conflicts over land use, sewage, and property rights for years threatened the very existence of floating homes in Seattle.

Currently, there are approximately 500 floating homes spread throughout several communities on Lake Union and Portage Bay, which is significantly lower than the Floating Homes Association

1950 report of 2,000 houseboats in Seattle at that time. Due to a shortage of accurate records and a lack of early regulation over houseboats, exact numbers are difficult to track. However, it is estimated that the number of houseboats across the city of Seattle peaked in the late 1930s. A 1939 Works Progress Administration survey for the Seattle Housing Authority documented a total of 946. After decades of evictions, including the removal of all houseboats from Lake Washington in 1938, the loss of over 50 moorage sites to the State Route 520 bridge construction, the replacement of several docks with the National Oceanic and Atmospheric Administration (NOAA) research facility on Lake Union, and countless other smaller land-use changes, the number of floating homes today is significantly lower than in the past.

The Seattle Floating Homes Association (FHA) was formed in 1962 to represent the values and concerns of the community to the greater Seattle public. Early efforts to organize were slow, but more residents became active as conflicts with landlords resulting in rent increases and evictions increased. The FHA remains active today, and its newsletter serves as the only continuous record of changing community character and major events over the past 50 years. Chapter four is a further exploration of the evolution of the FHA and its efforts to engage with the larger Seattle community. The first history of the Seattle houseboat community was written by Howard Droker, who was hired by FHA executive secretary Terry Pettus to document the community's history. His 1977 book *Seattle's Unsinkable Houseboats* was a valuable resource for this book and provides greater detail on some of the historical events mentioned here.

Seattle's Floating Homes builds upon the written history of the community and shares its stories through photographs. Very few photographs exist of houseboats prior to the 1950s because they were not regarded as property assets until the 1970s. Therefore, archival documents pertaining to ownership, property values, and the architecture of the homes are rare. The majority of long-term residents who were witness to the early organization of the community are gone, although those who remain have incredible stories to tell. Some residents have kept meticulous photograph albums and share their stories willingly, and it is because of them this book can be written. Perhaps this book will inspire more stories and photographs to be shared and archived, particularly in honor of the 50th anniversary of the Floating Homes Association in 2012. Above all, this book is written for readers outside of the community to gain an understanding of the character and complexity behind Seattle's floating homes.

One

FLOATING HOMES AND COMMUNITY ORIGINS

Floating homes in the Pacific Northwest began as wooden shacks built on logs to provide affordable and convenient housing for logging workers in the 1880s. Communities of houseboats for working-class residents were located on Elliott Bay, the Duwamish River, Portage Bay, and Lake Union. There were also houseboats on Lake Washington, which functioned primarily as summer homes for wealthier residents. Historically, this predominantly working-class housing was unregulated, not connected to city infrastructure, and considered a fringe, alternative, and lower-class part of society.

The community today consists of approximately 500 floating homes, limited to the shores of Lake Union and Portage Bay. The houseboats on Elliott Bay were the first to disappear as tidelands were filled to extend downtown and the health department issued evictions in 1908. In 1910, Congress authorized funding for the shipping canal between Elliott Bay and Lake Washington, and houseboats housed some the construction workers. On the Duwamish River, houseboats were replaced by expanding industry, although one resident held out until the 1970s (his story will be shared in chapter three).

Between property disputes, evictions, and increasing restrictions, it is remarkable that floating homes have survived in Seattle at all. When sewers were established around Lake Washington in 1938, houseboats were required to connect. Organizations such as the Waterfront Improvement Club took advantage of the opportunity to organize evictions. The challenge and cost of connecting to the sewer, in addition to eviction efforts, resulted in the end of houseboats on Lake Washington. Many of those were relocated to Lake Union and Portage Bay—where eviction efforts failed because sewers were not even established—and still exist today.

In the 1950s, the city began issuing regulations for houseboats, which gradually gained them acceptance but also began changing the character of the community. Although the City of Seattle dumped sewage into its surrounding waters as well, the houseboats continued to be a scapegoat for greater pollution problems, as many upland residents considered them undesirable. The establishment of the Floating Homes Association and its efforts to improve the reputation of floating homes—particularly through connecting to city sewers in late 1960s—was a critical step toward stability and survival of the community in Seattle.

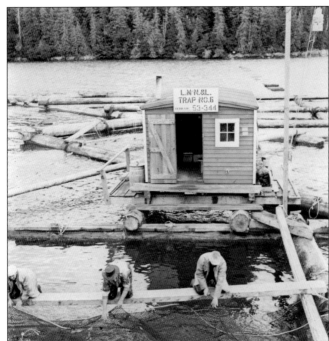

One of the earliest known images of houseboats shows three men cutting a log in front of a wanigan, the name given to a type of floating housing built for logging industry workers in the early 1900s. These homes were constructed on discarded logs from sawmills. Logs from areas that had burned are particularly water resistant and valuable as flotation. (Courtesy of the University of Washington Library, Special Collections Division, UW 29887z.)

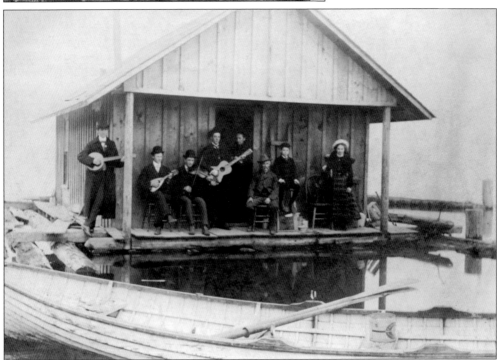

In this 1902 photograph, the Schahn family is pictured on their houseboats located near Rainier Beach on Lake Washington. This image of resident musicians provides an early example of the creative culture that has long been associated with the floating homes community. This also reveals that large families often lived in homes that were small relative to modern standards. (Courtesy of the Seattle Municipal Archives, 66254.)

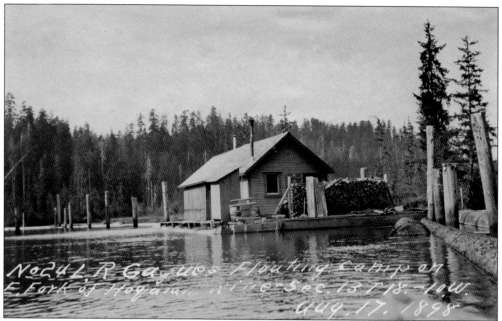

This floating structure was part of the L.R. Gaques floating logging camp, which was located on the East Fork of the Hoquiam River near the coast southwest of Seattle. The small structure was built up on a platform over floating logs, a precursor to modern floating homes. The photograph was taken by L. Heath and is dated August 17, 1898. (Courtesy of the University of Washington Library, Special Collections Division, UW 15508.)

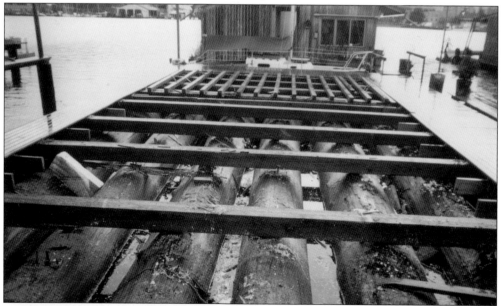

Large logs have been the traditional method of flotation for houseboats in the Pacific Northwest region, dating back to shacks that housed logging industry workers. The logs are stacked in an inverted triangle that extends well below the surface of the water. Some of the logs still in use as flotation are over 100 years old and can be reused when a home is rebuilt. (Courtesy of Marilyn Robertson.)

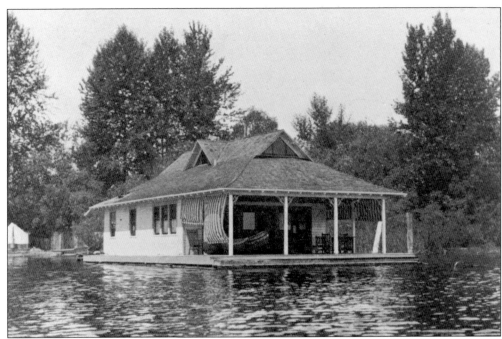

This c. 1905, middle-class houseboat on Lake Washington is representative of the types of houseboats that were around the Madison Park and Leschi neighborhoods. Although not a particularly large structure, the well-designed hip roof with dormer windows, carved wood posts, and ornately furnished interior reflect the relative wealth of the owner. The interior features wood paneling, a wood-burning stove, a large Oriental-style rug, and electric lighting, which was fairly new in residential use at the time. (Both, courtesy of the Webster & Stevens Collection at the Museum of History & Industry, Seattle, 1983.10.7356.1 and 1983.10.7356.3.)

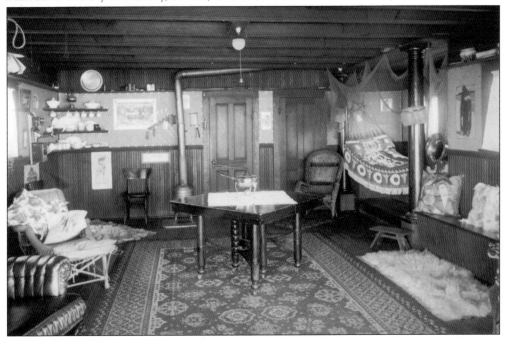

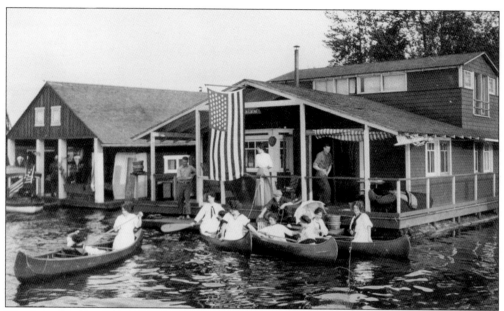

This houseboat was photographed on Lake Washington in 1912. It was likely used as a recreational summer home, indicated by women boating in white dresses with parasols. The house was relocated to the western shore of Lake Union when houseboats were evicted from Lake Washington in the late 1930s and is now owned by Dick and Colleen Wagner. (Courtesy of the Museum of History & Industry, Seattle.)

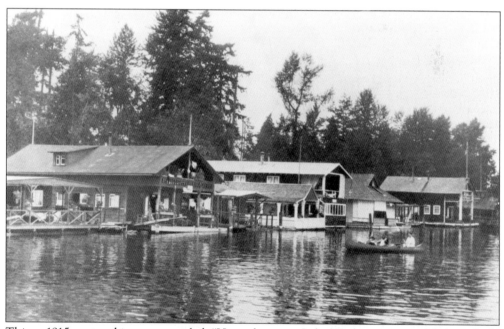

This c. 1915 postcard image was titled, "House-boats on Lake Washington near Madison Park, Seattle." The title is evidence that the term *floating home* had not yet been established to make a distinction among houseboat types. (Photograph by Nowell and Rognon; courtesy of the University of Washington Library, Special Collections, Seattle Postcard Collection, SEA 2057.)

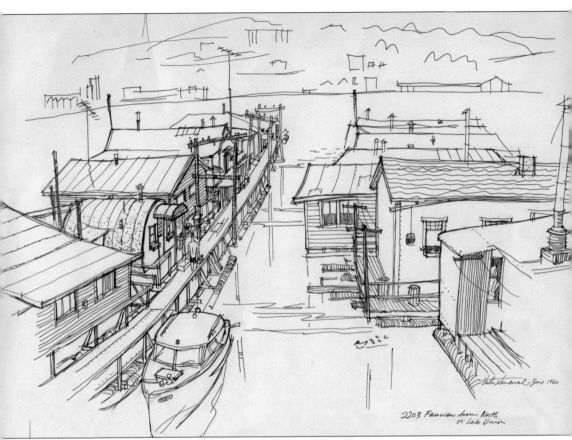

2203 Fairview Avenue North
on Lake Union

This hand-drawn sketch of a shoreline view into the floating homes community on Fairview Avenue East was drawn by Seattle architect Victor Steinbrueck. He was actively involved in efforts to save historic features of Seattle, including the Pike Place Market and the floating homes. This particular sketch—and the sketches on the next page of individual floating homes—were completed for the two-part series *Seattle Cityscape* (University of Washington Press 1973), in which Steinbrueck illustrates diverse scenes of Seattle architecture and culture. Steinbrueck wrote in the second book of the series, published in 1973, "It would be unfortunate if this colorful style of living were lost to the city, even though a new, expensive breed of quality-designed luxurious contemporary houseboats is beginning to appear." (Courtesy of the University of Washington Library, Special Collections, 29889z.)

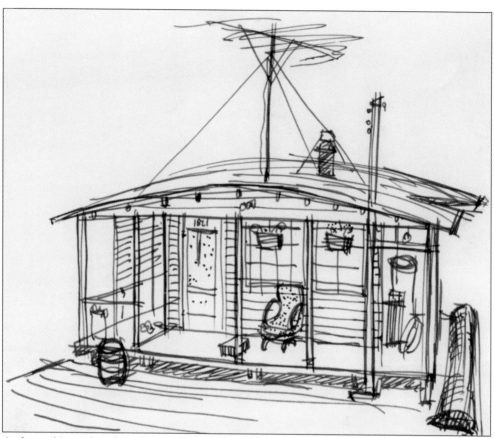

Architect Victor Steinbrueck captured the detailed character of the floating homes as well as that of the larger community. The sketch above is of typical sprung-roof floating home, in which the roof structure was formed by curving beams and lapping roofing material across, similar to boat building techniques. The home below has a particularly nautical style, with its porthole windows. Both sketches express the modest scale and working-class character of the homes in the 1970s. The homes have exposed utilities, laundry hung out to dry, and simple architectural detailing. (Both, courtesy of the University of Washington Library, Special Collections, 29890-29891z.)

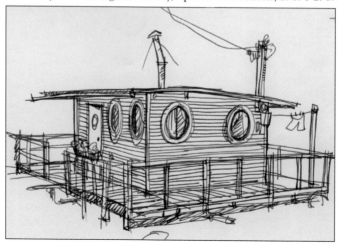

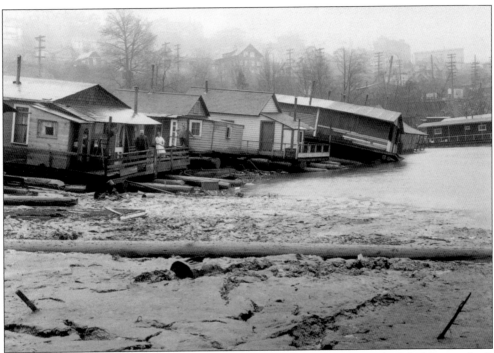

Houseboats around Lake Union were beached after the wooden dam, which held water back during the ship canal construction in Fremont, broke in 1914. The water in the area dropped 10 feet, causing damage to approximately 200 houseboats, including these along Fairview Avenue East between Newton and Blaine Streets. (Courtesy of the Webster & Stevens Collection at the Museum of History & Industry, Seattle, 1983.10.9810.1.)

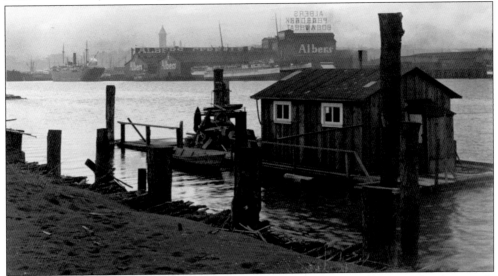

A houseboat is pulled by a tugboat near Harbor Island on the Duwamish River. The photograph is not dated but was probably taken between 1905 and 1930, based on the career of photographer Calvin F. Todd. The small, simple, wooden structure is representative of the types of houseboats common to the Duwamish area. (Courtesy of the University of Washington Library, Special Collections, Todd 118.)

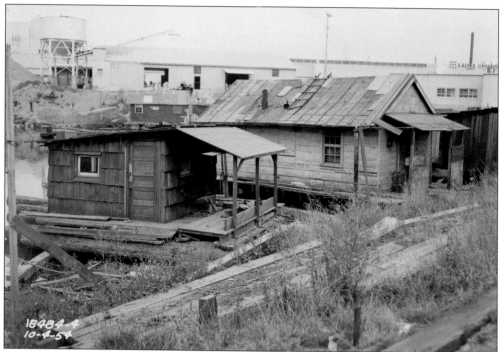

These photographs are from a series entitled "Slum House Boats." This community of houseboats on the Duwamish River was documented on October 4, 1954, by the engineering department of the City of Seattle. The title of the series reflects the city's attitude toward the community here, which it was surveying for industrial expansion projects that would eventually replace the houseboat community on Duwamish River. The community from this series was located near the First Avenue South Bridge on the mouth of Duwamish. (Both, courtesy of the Seattle Municipal Archives, 45982 and 45984.)

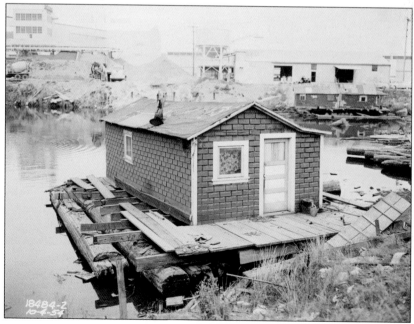

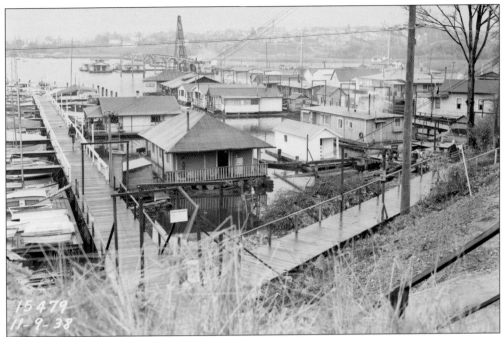

Houseboats were once located on Union Bay, between Lake Washington and Portage Bay, near the University of Washington. This photograph shows several houseboat docks on Union Bay and was taken by the engineering department of the City of Seattle on November 9, 1938. (Courtesy of the Seattle Municipal Archives, 38728.)

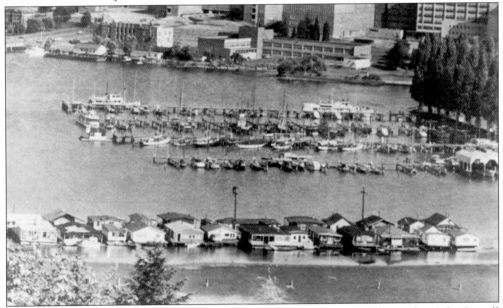

This aerial photograph of the Burley Moorage on Portage Bay was taken by resident John Pursell in 1960. Not long after John purchased his houseboat, he learned that the moorage was scheduled for replacement by the State Route 520 Bridge construction. Some residents, including John, were able to find moorage space for their homes at the end of other docks in Portage Bay and Lake Union. (Courtesy of John Pursell.)

Two

LIFE ON THE WATER

People have always been drawn to reside on or near water, and Seattle's floating homes are just one manifestation of that aspiration. For some, houseboats have doubled as homes and businesses. For others, the appeal was the simple lifestyle, sense of community, and proximity to water. Opportunities to swim, encounter wildlife, observe weather, and watch passing boats are reasons people love life on the water. The play of reflected light and sounds of water lapping against the docks make for a relaxing environment. Living on the water has also made humans closer to nature's forces. Windstorms and snowstorms create havoc for floating homes exposed to the elements, knocking down trees, causing homes to come loose from moorings, and even sinking homes under the added weight of snow. Enjoying and surviving the elements are experiences shared by those who make their homes on the water.

Living on the water is not unique to Seattle's floating homes; they are part of a larger phenomenon of houseboats. Seattle is also home to a variety of house barges and live-aboard boats previously discussed. Various forms of residences, identified as houseboats, exist around the world. Notable communities can be found in Amsterdam, London, India, and Southeast Asia. In the Pacific Northwest, communities of houseboats exist in and around Portland, Oregon; Sausalito, California; and Vancouver, British Columbia, Canada.

Seattle's floating homes are unique in the Pacific Northwest region for their central urban location, density of dwellings, and their community organization. The Sausalito's houseboat community, outside of San Francisco, evolved from summer recreational boats typically called arks. The community is known for inventive designs, such as one home that looks like an owl and another constructed from a split train car. The floating homes of Portland, Vancouver, and Seattle all originated from the logging industry. Vancouver's floating homes are primarily in the Delta region along the Fraser River, with a single dock near downtown at Granville Island. Portland's floating homes are located along the banks of the Willamette River outside of downtown and vary from individual floating homes to organized community docks. This chapter shares these diverse communities of people who live on the water.

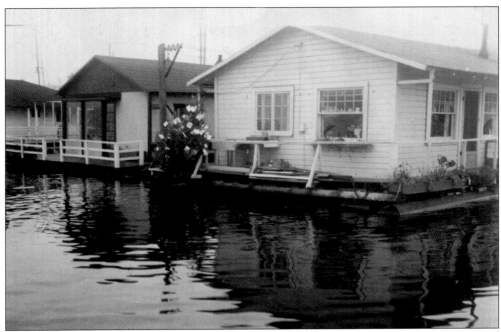

Unlike other types of houseboats, floating homes are designed to float in a single location called a moorage and cannot move on their own. A strong sense of community among neighbors has traditionally been one of the benefits of living closely together on the water. This c. 1960 photograph was taken on the shores off Fairview Avenue East. (Courtesy of Lynda Shelton.)

Other types of houseboats are present on the waterways of Seattle in addition to the floating homes. On the left is a house constructed on a barge base, and on the right is a boat converted into a home. Both are registered as vessels with the Coast Guard. (Photograph by author.)

As seasons change, residents of the floating homes are particularly attuned to patterns of weather and light because they are much more exposed to them. Although some residents have extensive gardens and an occasional tree, there is not much shelter from the elements on a typical dock. Light reflecting off the water on a sunny day provides visual entertainment in this Westlake home. (Author's collection.)

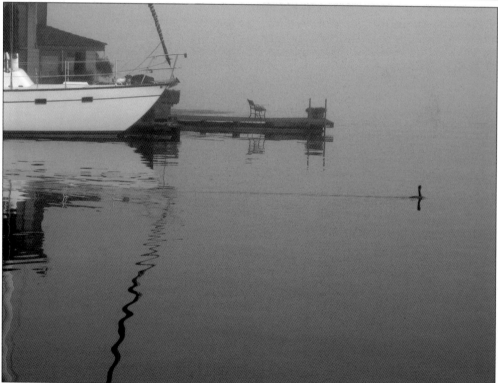

A very foggy morning in Westlake can cause the rest of the lake to disappear, leaving the floating home with a sense of isolation in nature. The change of light and weather are a part of daily life for those who live on the water. (Courtesy of Loretta Metcalf and Jim Healy.)

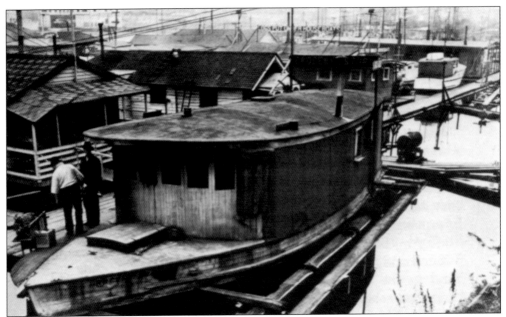

In the 1930s, Amelia Batrack used a boat to run a small grocery store that served residents of the floating homes community in Seattle, an example of employment opportunities within the neighborhood. This 1938 photograph shows signs for the grocery boat as well as a sign for a home-flotation business. (Courtesy of Howard Droker.)

Another example of small businesses in the floating homes community were the "tiny tankers" used to deliver oil to residents, which allowed them to warm their homes on Lake Union and Portage Bay. This particular tanker was formerly known as the *Blondie*. Rob Marsden restored the old tanker and is shown taking her for a cruise on Portage Bay in 1974. (Courtesy of Mack Hopkins.)

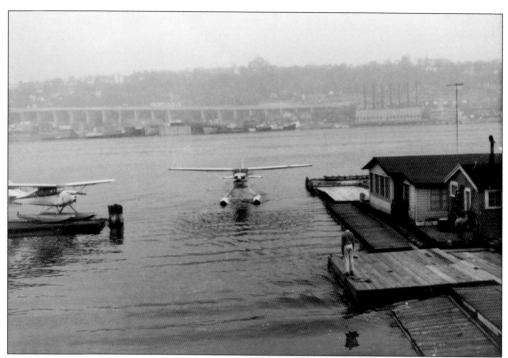

Floating homes have always shared the waterways with other businesses, including the float planes. In this photograph from November 1962, pilot Bill Roll lands a Sesna 180 on the ramp of Lake Union Air Service, owned by Hank Reverman. The commercial planes landed and took off immediately adjacent to the floating homes, visible at the right. (Courtesy of Bill Roll.)

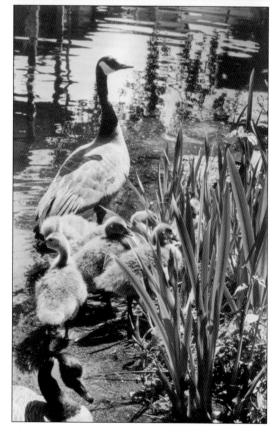

Floating home residents typically have positive relationships with the animals that make their home on the water. One exception is a nesting goose, which can be very territorial, loud, and aggressive. A mother goose that was successful in nesting around the floating homes stops to share her young with resident photographer Phil Webber. (Courtesy of the FHA.)

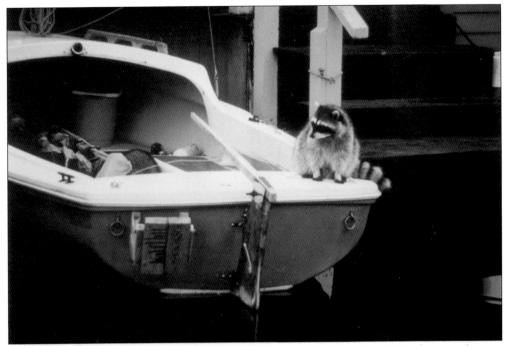

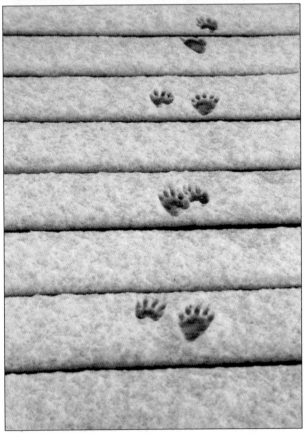

In this late 1970s photograph taken by Richard Droker, a family of raccoons decided to make their home in a private boat anchored among the floating homes off Fairview Avenue East. Residents enjoy telling stories of encounters with animals, most commonly raccoons, geese, ducks, otters, and an occasional beaver. Resident Michael Dederer recalls the night an industrious beaver took down four out of five alder trees that were growing in front of a neighbor's home. Paw prints in the snow can be another indicator of animal activities. (Above, courtesy of the FHA; left, courtesy of resident Betty Swift.)

As Lake Union and Portage Bay have been cleaned up over the years, more people have started to enjoy being in the water as well as living over it. Playing in the water is a pastime enjoyed by all ages. Residents George Yanakis and Debbie Royer jumped off the dock to celebrate their marriage in 1984. (Courtesy of the FHA.)

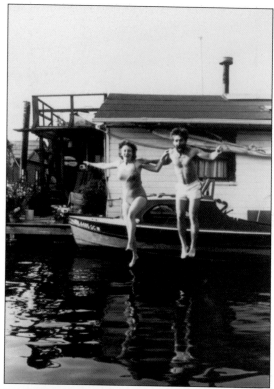

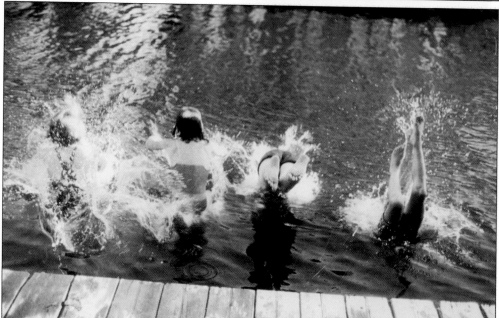

Children who grow up in the floating homes community have the chance to connect with the water from a young age. A group of kids dive into the water off the docks along Fairview Avenue East—girls feet first and boys head first. The c. 1980 photograph was taken by Anita Coolidge. (Courtesy of the FHA.)

The approach to raising kids on the docks varies from parent to parent. As a toddler visiting her grandmother's floating home, Lynda Shelton would play on the unenclosed docks under supervision, as shown in this 1944 photograph. A picket fence around the floating home kept grandkids from falling into the water, which was a good idea since there were no sewers at the time. (Courtesy of Lynda Shelton.)

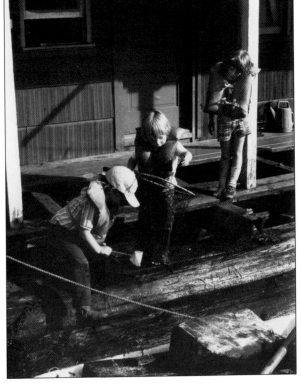

Kids trying to catch crawfish among the logs of a floating home are wearing life jackets for safety near the water. Pictured from left to right are Mark Haslett, Christopher Knight, and Jessie Good. This photograph was taken by Art Holder at a stringer replacement party on the Log Foundation docks along Fairview Avenue East in 1975. (Courtesy of Jann McFarland.)

As kids in the floating homes community get older, they are trusted on the water without life vests or supervision. These two girls paddled around during the 1975 stringer party while their parents worked. The girl on the left is unidentified, and Jill Sherensky is on the right. The photograph was taken by Art Holder. (Courtesy of Jann McFarland.)

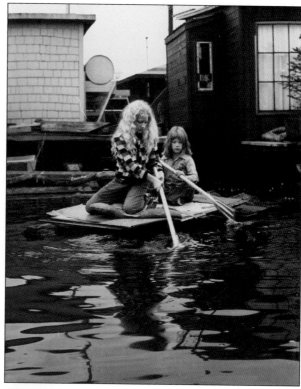

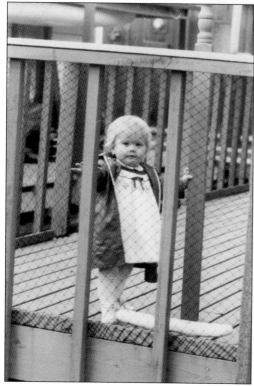

In 1981, Karen Keasler's parents put up a fence around their floating home to keep her from falling into the water. Creative parents devise strategies to keep their kids safe, and children learn to swim from a young age. Many residents note that there are not as many children on the docks as there used to be. (Photograph by Caryl Keasler; courtesy of the FHA.)

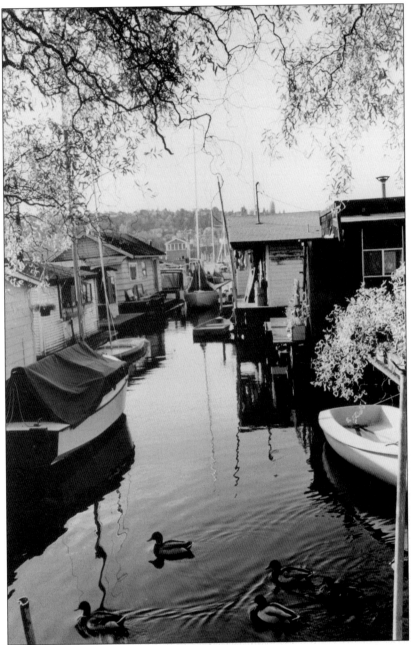

This photograph was taken from the shore looking down a waterway between the two floating home docks of the Tenas Chuck moorage, located along Fairview Avenue East and on Lake Union. The image captures a glimpse of one of the many scenes of tranquility that are often enjoyed by those who choose to make their homes on the water. The glassy surface of the water near shore is sheltered by the homes and is disrupted only by a group of passing ducks. This image was taken around 1980 by Phil Webber and was used as the cover image for *Floating Kitchens* (1994), the cookbook produced and sold by the Floating Homes Association. In the eclectic cookbook, community residents share favorite recipes for food and drinks, drawings of the docks, and stories from life on the water. (Courtesy of the FHA.)

A contrast to the previous scene of tranquility, but also a pleasure for floating home residents, is the fact that there is often something happening on the waters outside the window. Each year, residents get a particularly action-packed view of the Opening Day of yachting season. This photograph was taken on the deck of a floating home in the McInnes dock on Portage Bay in 1970. (Courtesy of Mack Hopkins.)

Otto Leonardt, a former resident of the floating homes community at the McInnes dock, made it an annual tradition to celebrate Opening Day along with the passing boaters. This photograph was taken in 1969. (Courtesy of Mack Hopkins.)

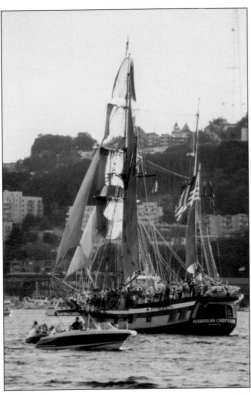

The *Hawaiian Chieftan* was part of a group of old, wooden sailing ships that sailed around Lake Union in 2002 as part of a Maritime Heritage tour. Residents in the floating homes community on the lake enjoyed front-row seats for this show from porches and roof decks. (Courtesy of Michael Dederer.)

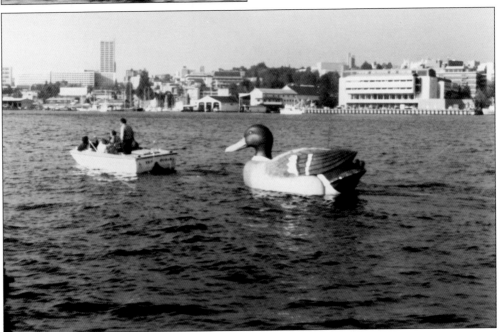

A longtime resident of the floating homes community likely has quite a collection of interesting stories of sights seen along the waterfront. One unusual surprise on the McInnes dock one day in 1970 was a large wooden duck being towed behind a small boat. No one knows the story behind this curious passerby. (Courtesy of Mack Hopkins.)

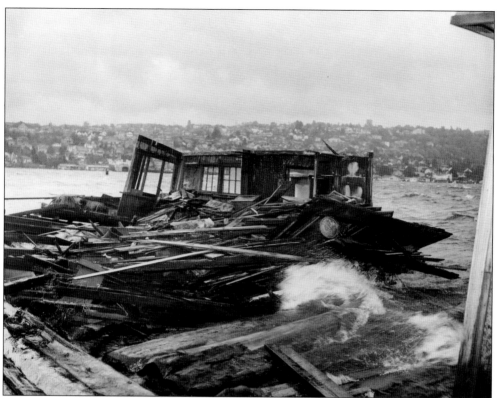

Unfortunately, life on the water is not always tranquil. This photograph shows the remains of a floating home that was destroyed in the gale storm that hit Lake Union on October 22, 1945. Floating homes are more exposed to the elements on the open water and can be disconnected from their moorings if not well maintained. (Courtesy of the Museum of History & Industry Archives, Seattle, Post-Intelligencer Collection, PI22327.)

Residents of the floating homes community know the potential risk of living on the water and do not hesitate to help a neighbor in need, even in the middle of the night. Phil Webber works with neighbors to prevent homes from being lost in a storm in 1986. (Courtesy of the FHA.)

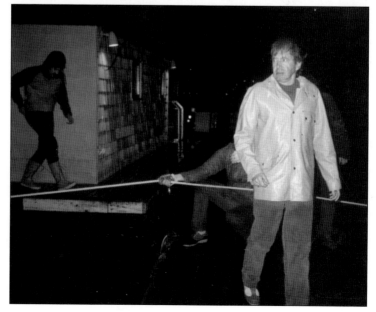

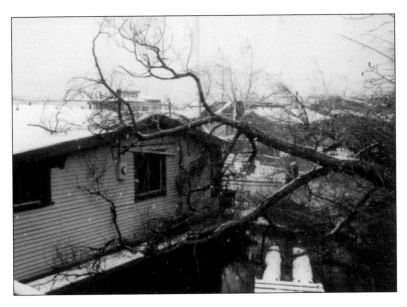

A tree that fell onto the home of Bill and Caryl Keasler as the result of a 1989 snowstorm did not result in the loss of the home or any lives, but it caused significant damage and did result in the loss of the tree. (Courtesy of Bill Keasler.)

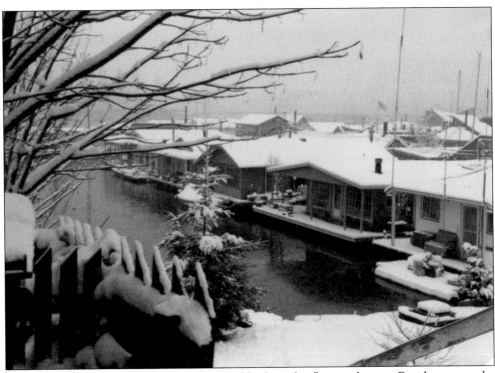

Snow on the McInnes dock in Portage Bay blankets the floating homes. Residents must be careful not to let too much snow sit on the roof, or else the additional weight can cause the home to tip over or sink. This photograph was taken following a snowstorm in 1970. (Courtesy of Mack Hopkins.)

An image taken from the Lee's Moorings dock in Fremont may be of the same snowstorm that hit Portage Bay in 1970. When no home is in danger of sinking, it is possible to stop and enjoy the peaceful winter view of sun on the snow. (Courtesy of Sylvia Hubbert.)

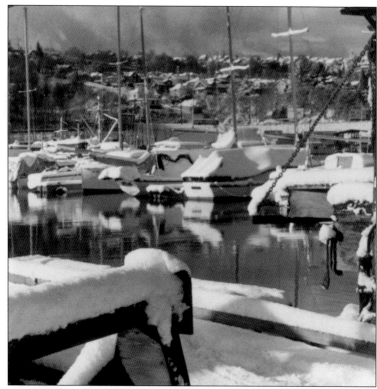

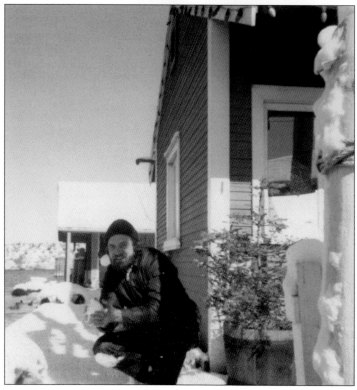

University of Washington architecture professor emeritus Jim Donnette stops to play in the snow in front of his home at the Tenas Chuck moorage after the 1970 snowstorm hit Lake Union. The Donnettes have called the community home since the 1960s and raised two children in their small floating home. (Courtesy of Jim and Barbara Donnette.)

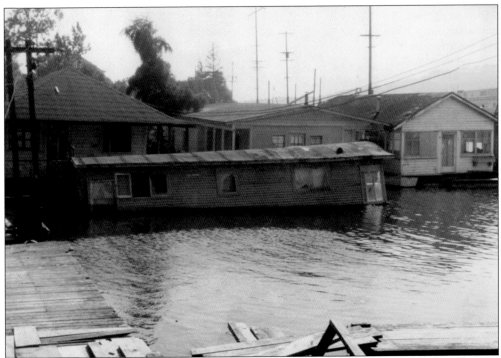

A floating home in the process of sinking was documented in 1964 near today's Roanoke Reef moorage along Fairview Avenue East. The cause of this particular sinking is unknown, but potential culprits could have included wind, snow, or faulty flotation. (Courtesy of the FHA.)

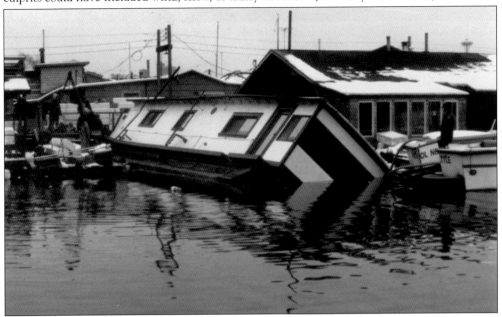

A house barge owned by Ed and Karen Hayes sank overnight in a snowstorm in December 1985. The weight of the snow on the roof was more than the flotation could bear. They were forced to rebuild and chose to construct a floating home instead of another barge home in their Fairview Avenue East moorage. (Courtesy of the FHA.)

After the Hayes' house barge sank, community resident and builder Tom Susor helped them construct a new floating home at their moorage. In this photograph, Tom throws up his hands to show frustration at the city's requirement of proof that logs could float before approving the use of them in his proposed design. (Courtesy of the FHA.)

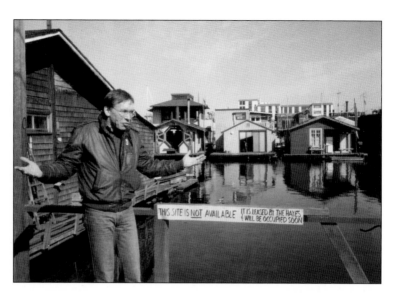

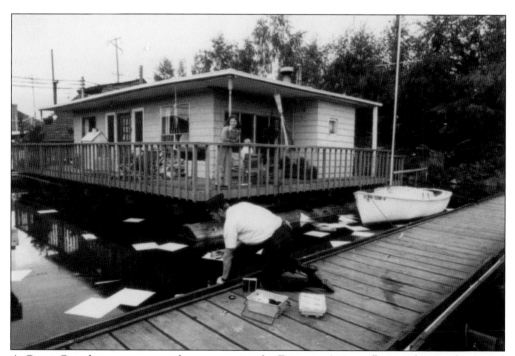

A Coast Guard inspector tests the water around a Fairview Avenue floating home after an oil spill occurred on Lake Union in 1982. Initial speculation was that the leak came from a floating home, but the near 200-gallon spill proved too large. Residents such as Ann Powell and her daughter were stuck living amid the mess until it was cleared up. (Photograph by Caryl Keasler; courtesy of the FHA.)

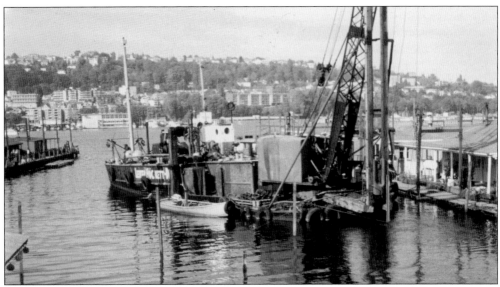

The connection to the sewers in the late 1960s was a critical step towards stability for the floating homes community. One of the significant distinctions between floating homes and other types of houseboats is that the former must be permanently connected to sewers. In this 1968 photograph, Leiter Hockett's crane barge, the MV 41, installs sewers at a group of docks along Fairview Avenue East. (Courtesy of the Mark Freeman Photograph Collection.)

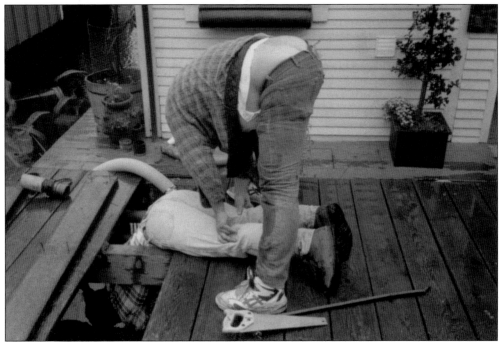

Creating a plumbing system for floating homes in the 1960s required innovative solutions that were spearheaded by floating homes residents, including former FHA president Ken Kennedy. Kennedy worked as a plumber and electrician around the community during the era of the do-it-yourself approach to floating home repairs. In this photograph, plumbers Russell and Tom work together to access plumbing under the docks at the McInnes moorage. (Courtesy of Mack Hopkins.)

Art Holder—a resident handyman often referred to as "the stringer man"—has led many community efforts to maintain and repair floating homes. In these photographs from the 1975 work party to replace the old stringers on Jann McFarland's floating home, Art documents the tightening of the anchorage system connected to the logs (right) and Tom Haslett hammering a stringer beam to the log flotation (below). Neighbors from the Log Foundation docks on Fairview Avenue East came out to help Jann and Art by donating their physical strength, cooking skills, or moral support. (Both, courtesy of Jann McFarland.)

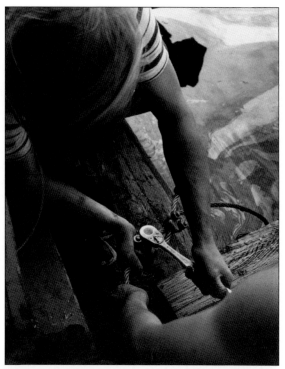

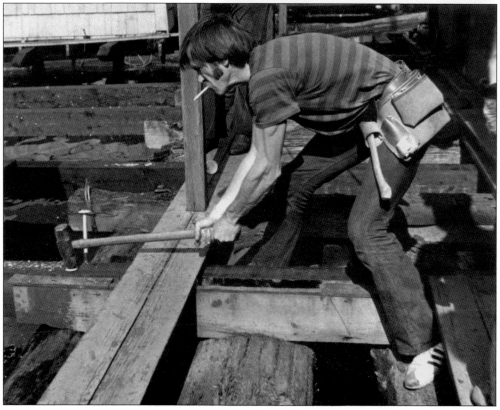

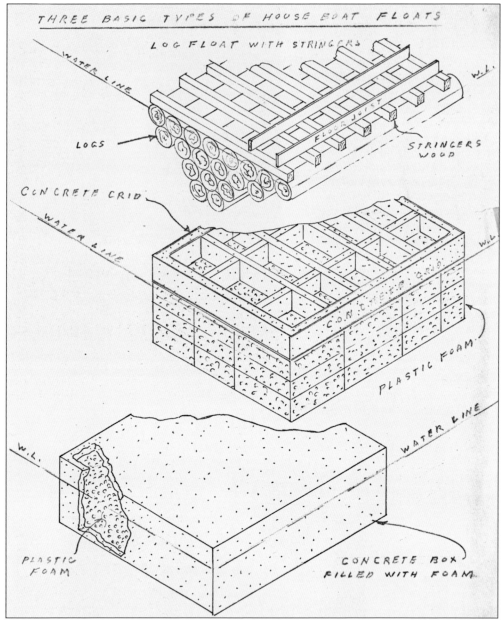

THREE BASIC TYPES OF HOUSE BOAT FLOATS

LOG FLOAT WITH STRINGERS

WATER LINE

W.L.

FLOOR JOIST

LOGS

STRINGERS WOOD

CONCRETE GRID

WATER LINE

W.L.

CONCRETE GRID

PLASTIC FOAM

WATER LINE

W.L.

PLASTIC FOAM

CONCRETE BOX FILLED WITH FOAM

This anonymous sketch from a 1975 issue of the Floating Homes Association newsletter details the various types of flotation systems used to support the community. The top drawing shows the traditional method of log flotation topped by stringer beams below the floor framing. By keeping the logs below the water line, they will be preserved longer. The middle diagram shows a concrete foundation based over foam blocks. This solution has also been adapted to include concrete casing around the foam to prevent degradation and pollution, as shown in the bottom diagram. Another solution now in use is to have a concrete basement manufactured and installed to displace water to achieve flotation. These basements are typically shallow spaces because the City of Seattle code restricts basement depth to protect shoreline habitat for juvenile salmon and other species. (Courtesy of the FHA.)

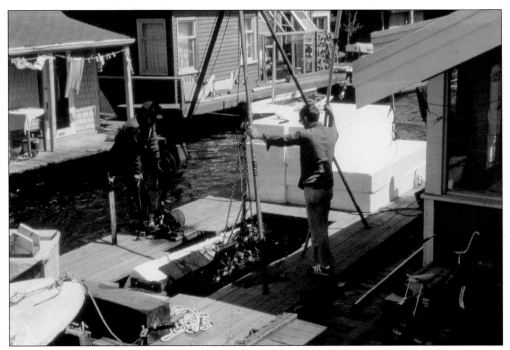

George Johnston prepares to install extra flotation in the form of foam blocks at a floating home at the Tenas Chuck moorage on Lake Union in 1970. George worked on the docks for years, adding foam blocks or empty plastic barrels to augment aging log flotation. Another flotation job is adjusting flotation to accommodate for additional furniture or the construction of a new home. (Courtesy of Jim and Barbara Donnette.)

Another evolving part of the infrastructure of floating homes has been the methods of heating a home. Wood burning stoves—such as the one Mack Hopkins found when he bought his Portage Bay home in 1968—have been a common solution still in use in some homes today. (Courtesy of Mack Hopkins.)

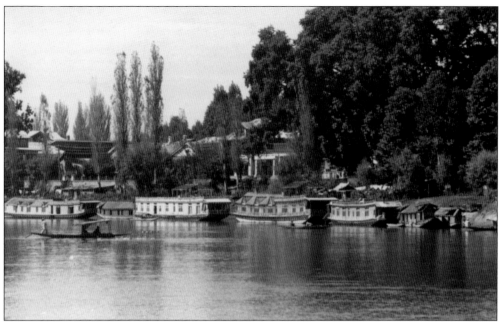

Seattle's floating homes are part of a global phenomenon of houseboats, such as these traditional houseboats on Dal Lake in Jammu and Kashmir, India. The houseboats in this region are constructed on barges, with varying degrees of mobility depending on where they are moored. Some are grouped along the shore like hotels (above), while others are more isolated, such as the one among lotus plants (below). Houseboat accommodations in northern India range from family-style bed and breakfasts to upscale hotels with private suites. These houseboats traditionally have ornate carved-wood paneling. The political situation in this region has negatively impacted the tourism industry that has long supported the maintenance of these houseboats, and it is unclear what the future holds for this floating community. These photographs were taken by Ed Waddington during a 1978 visit. (Both, courtesy of the FHA.)

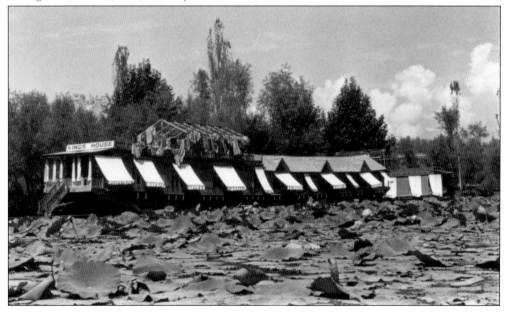

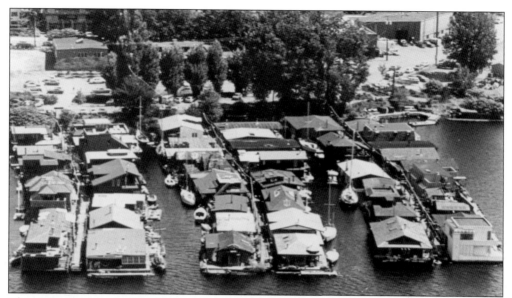

This 1979 photograph taken by Jonathan Ezekiel shows the Log Foundation docks on the eastern shore of Lake Union in Seattle. It is common for older docks in Seattle to contain closely packed homes because they were extended to accommodate homes evicted from other parts of the city over the years. (Courtesy of the FHA.)

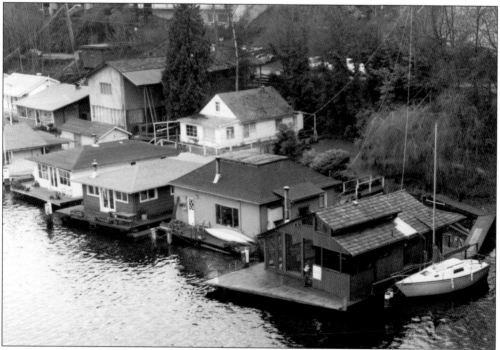

In Seattle, the floating homes along Portage Bay are commonly organized into smaller docks serving only a couple of homes because the construction limit line is closer to shore here. Floating homes exist in Portage Bay mostly because in 1909 the shore lands on Portage Bay were sold to upland owners to raise money for the Alaska-Yukon-Pacific Exposition. This photograph was taken in 1975 by Jonathan Ezekiel. (Courtesy of the FHA.)

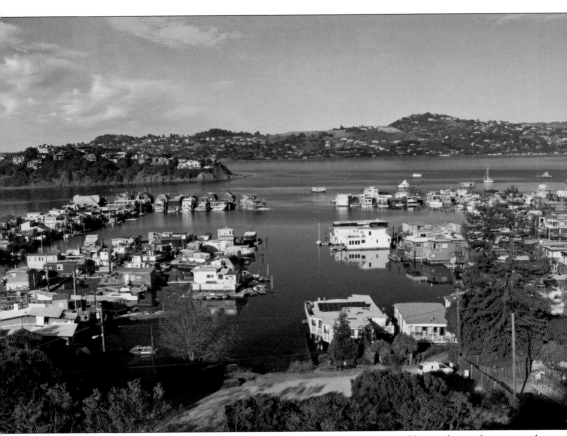

The houseboat community in Sausalito is an eclectic mix of live-aboard boats, house barges, and floating homes sheltered in a bay. Shortly after California achieved statehood in 1850, Richardson's Bay was subdivided into underwater lots to create a West Coast Venice, a city-planning trend popular in early California history. When the idea failed to materialize, the state sold the tideland lots into private ownership but retained the titles to a number of designated underwater streets, which still lead to political disputes today. People began living on abandoned ferries and houseboats made from surplus military vessels, in addition to arks on the nearby creeks of Larkspur. Around 400 houseboaters have since made the Sausalito community their home, and many people have started constructing larger floating homes in addition to the older boats and barges. (Courtesy of Emily Riddell.)

The homes in Sausalito are quite diverse, reflecting the character of the notoriously artistic and creative residents. This particularly unique floating home was constructed around an old train car that was split in half to form two sides of the living area. (Courtesy of Emily Riddell.)

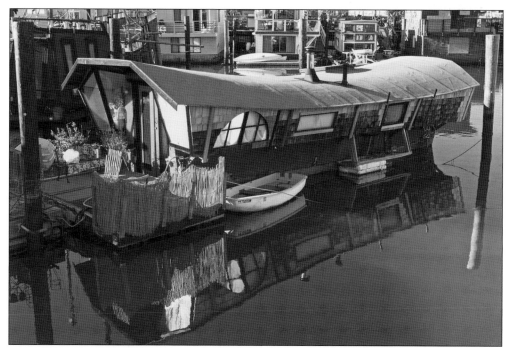

Some homes in Sausalito are built up on barges, such as the distinctly shaped structure shown here. The roof structure used on this house evolved from boat-building practices of lapping sheet materials over a curved-wood frame. This is known as a sprung-roof construction and can be seen on some of Seattle's floating homes as well. (Courtesy of Emily Riddell.)

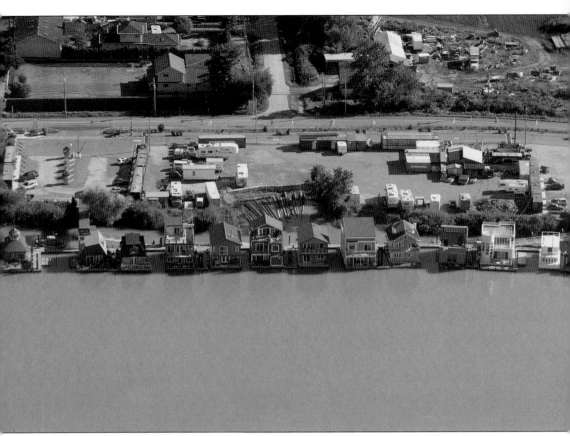

The typical dock formation in the Delta region outside of Vancouver, British Columbia, is one or two houseboats lined up along the edge of the Fraser River, as shown in this aerial image of Ladner Reach Marina. The type of houseboats in the Delta region ranges widely but includes some floating homes at permanent moorages. The community is much less concentrated and is dispersed throughout a more rural area than the Seattle community. Underwater lots are most commonly leased to the owners of the upland property by the Fraser River Harbour Commission. The Fraser River Estuary Management Program was established to coordinate waterfront interests and development in the area. The Floating Homes Association Pacific is the organization that regulates and organizes the floating homes community in Vancouver. (Photograph by Wendy Filippone; courtesy of Don Flucker.)

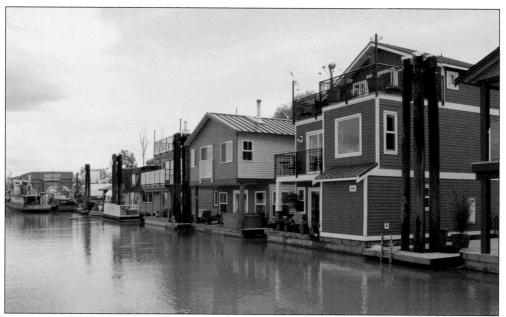

This 2006 photograph shows the Ladner Reach Marina, a moorage facility on the southern end of the Fraser River delta that is home to 28 houseboats. Ladner Reach Properties Ltd. owns the upland and marina facilities and leases the adjacent water lot from Port Metro Vancouver. The marina has 28 floating home berths and offers secure moorage contracts (Courtesy of Don Flucker.)

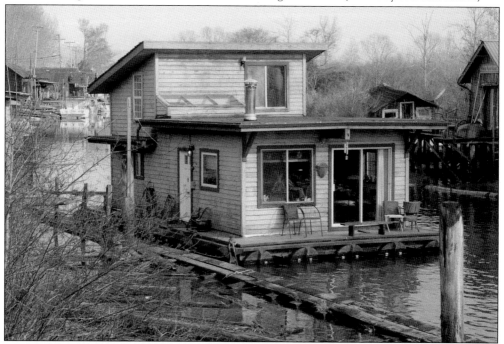

This 2010 photograph shows a smaller floating home in Finn Slough near Richmond. The lower arm of the Fraser River now has over 200 houseboats, which range from trailers on floats, to homes on barges, to floating homes. Unlike the waters of Seattle just to the south, this area is tidal, demanding greater flexibility out of moorage infrastructure. (Courtesy of Don Flucker.)

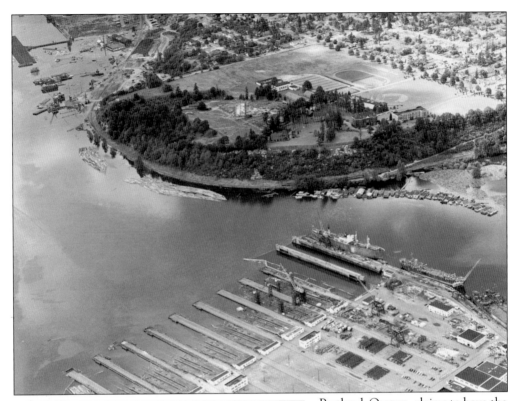

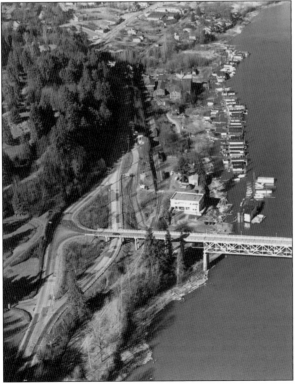

Portland, Oregon, claims to have the largest number of floating homes in the United States, with close to 600 homes. The community also evolved from the logging industry, as shown in the 1939 photograph (above) of the west end of the Sellwood Bridge, south of downtown. The former proximity to industry is illustrated in an aerial at Swan Island, north of downtown, taken on June 14, 1948 (left). The floating homes are located outside of the urban downtown area and are relatively stable, as there have been no recent drives to evict them. However, like Seattle, many moorage sites are over leased underwater property. In Portland, there is no code regulation on float size, but there are regulations on height limit, walkways, and spacing between the homes issued by the City of Portland. (Both, courtesy of the City of Portland Archives, A1999-004.1132 and A2010-001.124.)

Three

A COMMUNITY OF INDIVIDUALS

The floating homes community in Seattle is notable for its unique residents and the reflection of their personalities in the designs of the homes themselves. Many residents of the community express their passions creatively through the architecture of their homes. While privacy is respected on the docks by residents and requested from curious visitors, there is a collective spirit of activism, support, and celebration within the floating homes community. Recurring communal events have included the luau and pig roast held at 2025 Fairview Avenue East, the Bach on the Dock classical music night, Lake Union cleanup days, annual community meetings, and a biannual tour of homes offered to the public. The shared challenges of raising children, battling home-threatening storms, living in high density, and finding secure moorages have brought people together as a close community of individuals.

Some homes in the community are over 100 years old, and others have been expanded or remodeled over time. Many newer homes have been constructed by one of the local floating home architects or builders in the city who can make their design buildable without a level, which is of no use on the water. The smallest floating home is an efficient 450 square feet. On older docks, space is tight, as homes are often within a few feet of each other. The powerful community sentiment can be perceived by the number of welcoming porches, outdoor patios, and open doors and windows. Recently, the trend has been construction of floating homes built out to the maximum size allowed by building code, with no porch or dockside seating. This reflects the changing character of the community, from small, modest houses to traditional, land-sized houses. As real estate values and the acceptability of the community increase, only wealthier buyers can afford to join the community.

Architectural eclecticism and outward expression of character are traditions that have contributed to the charm of the floating homes community. This chapter shares the stories of some of the individuals and unique homes that represent the origins and allure of the floating homes community.

A floating home on Fairview Avenue East incorporates reclaimed pieces of natural wood into the design, giving it a character that is distinct from neighboring homes. The photograph was taken in 1979 as part of an inventory of the floating homes initiated by the City of Seattle, but it was never completed. (Courtesy of the FHA.)

Because of high real estate values, relatively new floating homes tend to be built out to the maximum size allowed by code, leaving no space for a front porch, planters, or distinction of form. The character of a dock filled with such visually dominant structures is distinctly different from docks of older floating homes. (Photograph by author.)

This aerial photograph from 1969 shows the configuration of the Shelby Street dock, giving a sense of the density on some docks. Although some homes have been remodeled since the late 1960s, many of the dock residents are the same. The dock formation does not appear to influence the sense of community as much as the forms of the homes and the attitudes of their owners do. (Courtesy of Mack Hopkins.)

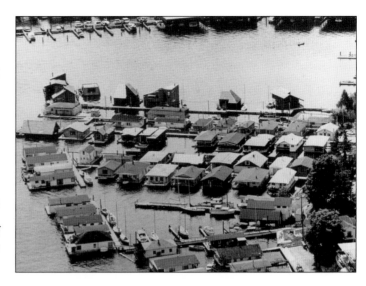

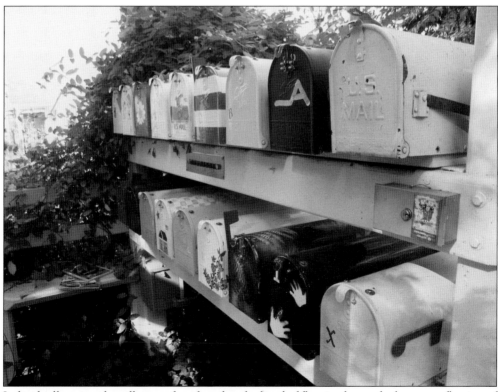

Individually painted mailboxes often found at the head of floating home docks are a reflection of the creative and diverse character of the residents. The community is home to many artists and creative individuals, although the real estate values have made the cost of living there a challenge for some longtime residents. (Photograph by author.)

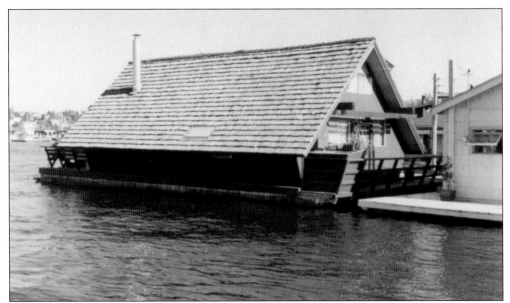

A floating home is not properly viewed in isolation because the surrounding community of other floating homes is a part of the quality of life. Although the home in this 1970 photograph was located across a spite dock established between the owners of two adjacent moorages, the residents on both docks were still friendly to each other. (Courtesy of Mack Hopkins.)

This image in taken in the 1960s is an example of what a dock can be like when a sense of community is not shared among residents. The owner moved his houseboat to the end of the dock, blocking the connection to the water for other residents. This gesture exacerbated tensions in the dock community, which were resolved when the residents cooperatively purchased the moorage from the owner, Gordon Jeffery. (Courtesy of the FHA.)

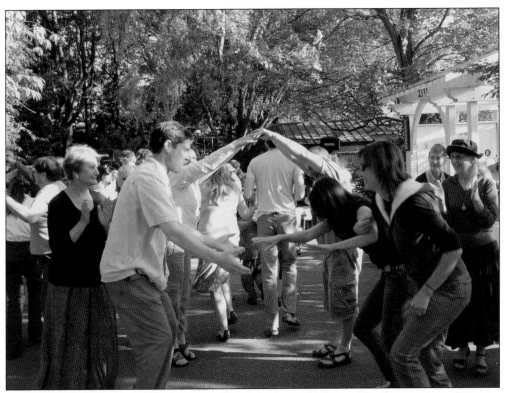

A pair of docks where a sense of community still thrives is the Tenas Chuck moorage on Fairview Avenue East. Residents dance together during an evening of Fiddler on the Dock, where the Canote Brothers played. Although Leslie Silverman was only a renter, she participated regularly in this event, as well as others, including Bach on the Dock, one of many dock traditions she recalls fondly. (Courtesy of Leslie Silverman.)

A man sits alone in the evening to read on the porch of his houseboat in Mallard Cove. Individual space and privacy do remain possible, even in such a close community. The photograph was taken in the 1950s by Michael Dederer when he lived in an apartment overlooking the houseboat community, which he now calls his home. (Courtesy of Michael Dederer.)

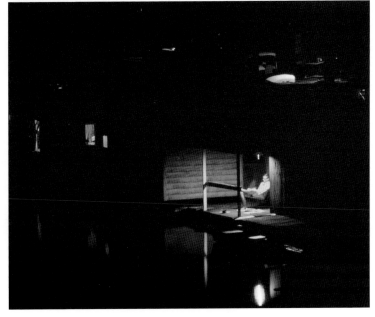

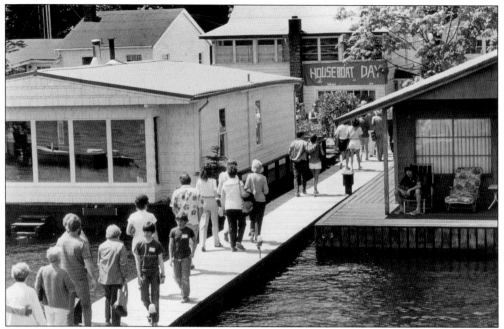

The public is welcomed for a visit down to the docks for the biannual houseboat tour, hosted by the FHA board and members of the community in the fall. Each year a group of homes are opened to ticket holders. The tours began in the early 1980s and continues into the present, selling out every year. (Courtesy of the FHA.)

The FHA tour allows visitors to see a community that is typically very private and can seem isolated from the rest of Seattle. It is a chance to share not only the homes themselves, but the vibrant culture of the floating homes community. Here, the tour visits the home of Mack Hopkins on the Shelby Street dock. (Courtesy of Mack Hopkins.)

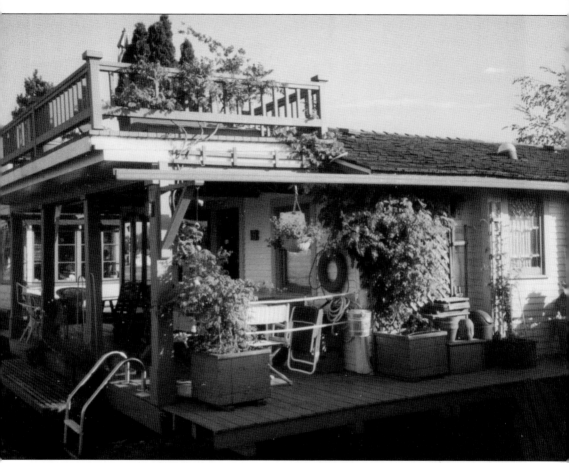

The architecture of the floating homes alone is a good reason to attend the FHA tour. Older, historic homes are moored next to brand new homes, with a bit of everything in between. This floating home on Shelby dock has gone through a series of upgrades since it was purchased by Mack Hopkins in 1968, but it still maintains a historic character and modest scale. Mack renovated much of the interior, upgrading plumbing, refinishing the kitchen, and adding a skylight. He also replaced the simple columns on the porch with some more elaborate turned wood posts. Each of these changes adds character and visual interest to the home. On a dock full of floating homes, there may be little outdoor space for residents to personalize. Often a front porch or small float is used to accommodate chairs, plants, and art. The most recent addition for Mack was a roof deck. Roof decks are common on the floating homes for chatting with neighbors, hosting parties, and enjoying the views, particularly during boat races or the Fourth of July fireworks. (Courtesy of Mack Hopkins.)

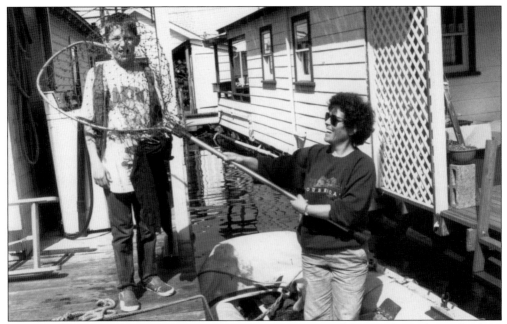

Since the late 1960s, Seattle's waterways have been transformed from industrial wastelands to valued cultural and recreational assets. The floating homes community has also evolved to become better stewards of the waters. Members, such as young Seth, caught in a net by Marty Greer, volunteer in the annual Lake Union Clean-Up Day. (Courtesy of the FHA.)

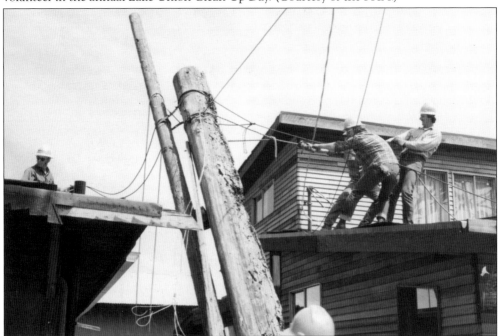

Keeping the docks clean and safe is a responsibility shared among community members. In this photograph from the Lees Moorings dock taken in 1975, replacing a utility pole between two floating homes takes a team of men. Utilities have since been moved under most docks, easing access, reducing fire hazards, and opening up views. (Courtesy of Sylvia Hubbert.)

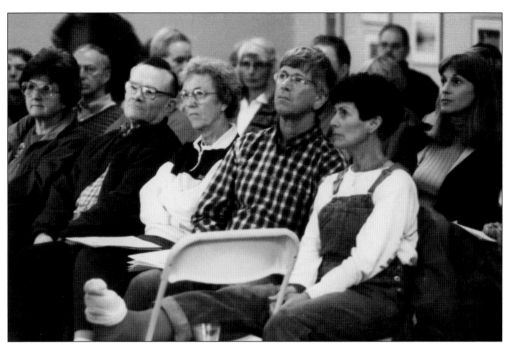

The Floating Homes Association, which will be explored in more detail in chapter four, organizes many community events that bring residents together across docks and waterways. The annual meeting draws over 100 people to socialize, hear speakers on current issues, and vote for board members and community policies. Members listen attentively to a speaker in this photograph taken by Phil Webber. (Courtesy of the FHA.)

At some FHA annual meetings, such as this one photographed by Phil Webber in 1981, entertainment is used to convey important messages while keeping everyone engaged. Father and son performers on this occasion are, from left to right, Tom Haslett on guitar, Mark Haslett, Chris Knight, and Jim Knight. (Courtesy of the FHA.)

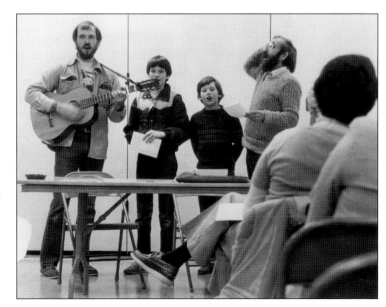

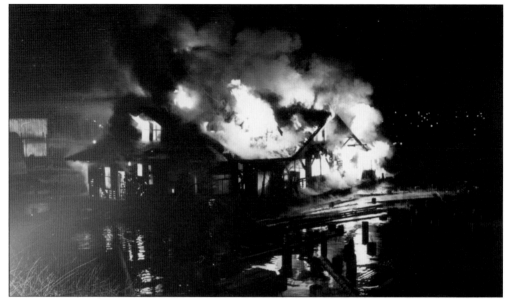

Sometimes what brings community members together is a more negative experience, such as an emergency. With homes close together and wood construction abundant, fire can be a serious hazard in the community. Neighbors work together to alert others, help elderly and disabled residents evacuate, and control flames until a fireboat can arrive. This image of a floating home fire was taken in 1980 by Jonathan Ezekiel. (Courtesy of the FHA.)

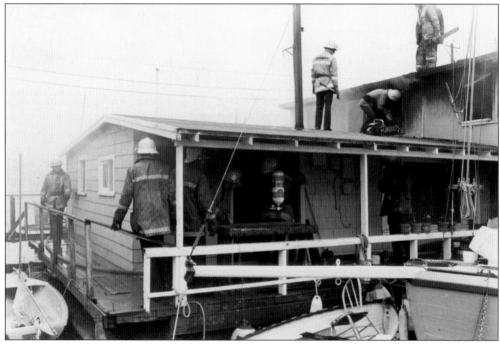

Firemen were able to contain the 1980 blaze and save neighboring homes but still keep an eye on hot spots and survey damage the next morning. The responsibility of residents to prevent hazards and the quick response by local firemen has improved over the years, resulting in fewer incidents of fire in the community. This photograph was taken by Jonathan Ezekiel. (Courtesy of the FHA.)

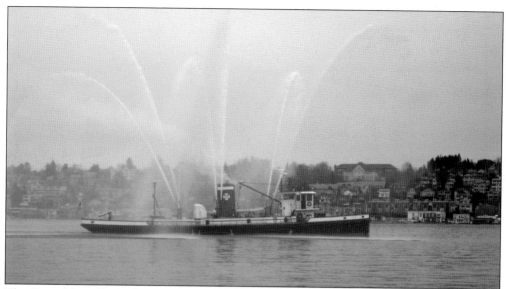

The City of Seattle's fireboat, equipped with fire hoses, puts on a show on Lake Union during a holiday celebration. In 1957, a city ordinance insisted 40 feet of open water be kept clear between houseboats to prevent fire issues. Fortunately, for the homeowners and community character, that regulation was changed and more reasonable measures have been taken to decrease incidents of fire, including improved firefighting capacity. (Courtesy of Loretta Metcalf and Jim Healy.)

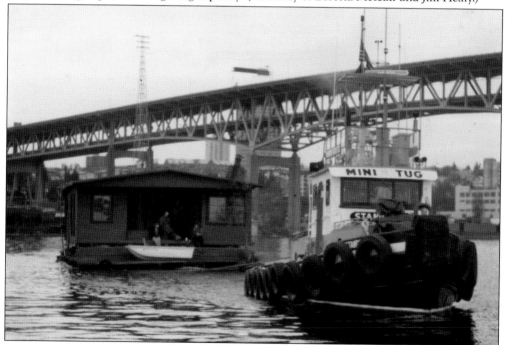

A more positive activity that brings the Lake Union community together is the process of relocating or replacing a floating home, known as a "shuffle." Here, the tugboat Standfast, owned by the Fremont Tugboat Company, helps to relocate a floating home from Portage Bay to Lake Union in 1987. This company has been working on the lake since 1915, and its small tugs are a perfect fit for working with floating homes. (Courtesy of the Mark Freeman Photograph Collection.)

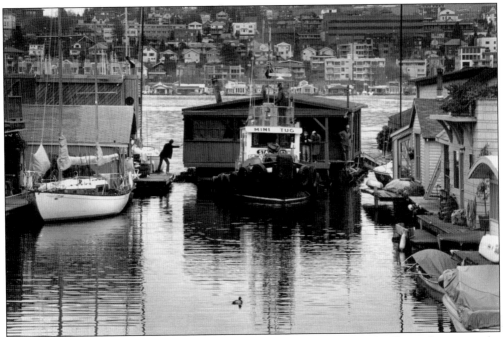

Community photographer Phil Webber was also there for the 1987 shuffle to document the relocation of Juliette Sauvage's floating home. She was evicted from her moorage on Portage Bay, as were many other floating home residents following rental disputes with moorage owners in the 1980s. Here, the home is arriving, with the help of the *Standfast* tug, at the entry to its new moorage on Fairview Avenue East. (Courtesy of the FHA.)

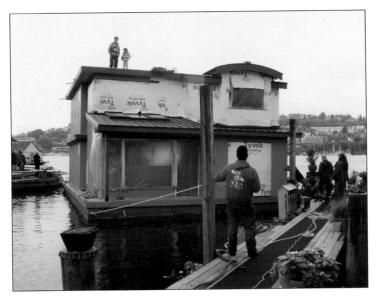

A new floating home designed by architect Eric Hogeboom is moved into place while owners and neighbors look on. Once a home is in place, all of the homes that have been shuffled out must be returned to their moorages, re-anchored to the dock, and reconnected to the public utilities. (Courtesy of Leslie Silverman.)

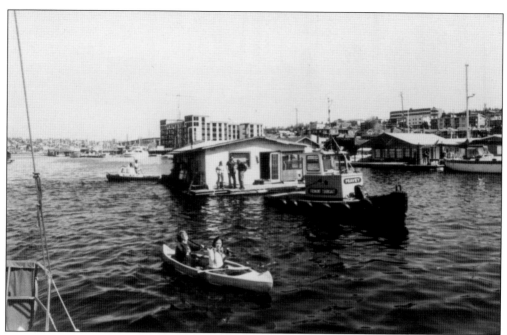

This photograph was taken during a 1982 shuffle to accommodate the evicted floating home belonging to Mike Douglas. He was evicted by his moorage owner, Frank Granat, but was fortunate to find space on another dock. The home is escorted along the shuffle route by a canoe and the boat from where this photograph was taken. (Courtesy of the FHA.)

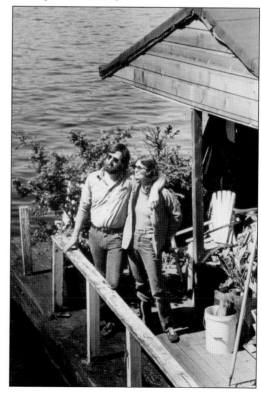

Floating home owner Mike Douglas enjoys the sun with his girlfriend on board his floating home as it is relocated to Fairview Avenue. A shuffle can be an all-day event, and many owners take the day to help disconnect and reconnect anchoring and utilities and enjoy the ride out into the lake. This photograph was taken by Phil Webber in 1982. (Courtesy of the FHA.)

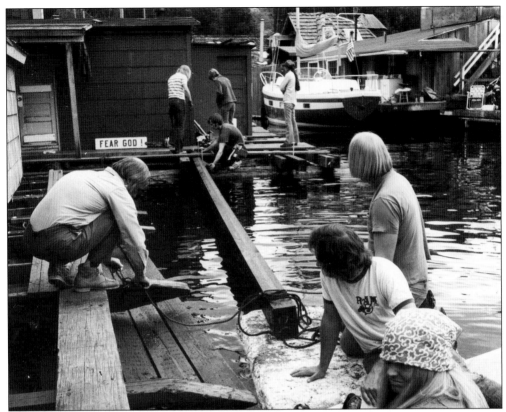

Another shared pastime of the do-it-yourself floating homes community is the stringer party, mentioned in the previous chapter. During a stringer party, neighbors come together to help someone replace the substructure of their home. Replacing stringers requires coordination, strength, and no fear of floating out on the water while lifting heavy objects. In the photograph above, the stringer party team at the front includes, left to right, Pat Grathwohl, unidentified, Doug Kimball, and Jann McFarland in the head scarf. In the photograph below, Martha Rubicam assists the team by boat. These photographs by Art Holder were taken during the 1975 stringer party at Jann McFarland's home on Fairview Avenue East. (Both, courtesy of Jann McFarland.)

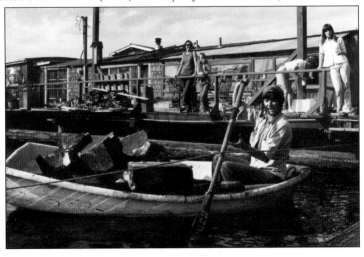

On the occasion of a home remodel, neighbors in the floating homes community have traditionally showed up to help get things done. This do-it-yourself remodel in 1980 involved the addition of a second floor to the floating home belonging to Jann and Sid McFarland, shown with framed walls in the image at right. The ridge beam installed on the new roof weighed in at 500 pounds, requiring a whole group of men to lift it into place. In the image below, the muscular men are, from left to right, Jim Brown, Steve Hansen, Clay Eaton, Jim Knight, Sid McFarland, Dave Gardner, and Ken Hopper. (Both, courtesy of Jann McFarland.)

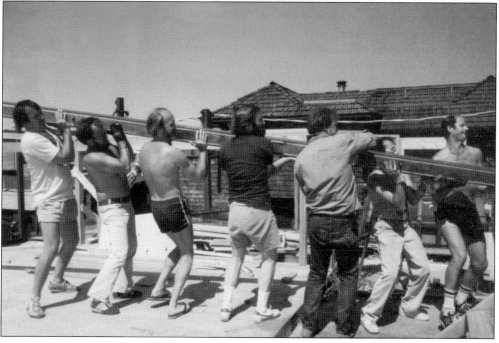

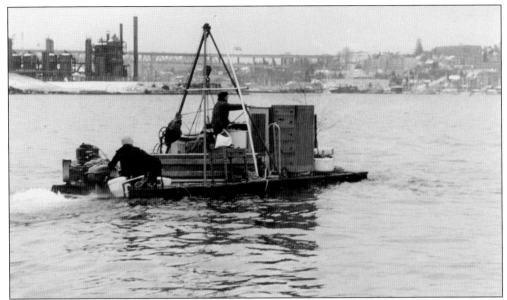

The process of moving when one lives on a floating home may seem easy when the entire house can be relocated by tugboat, but moving from one house to another by water presents a whole new challenge that requires creative solutions. George Johnston lived in the floating homes community and ran a service business that included flotation support, stringer replacement, and moving services. In these photograph from the early 1980s, George helps Sandy Ollien move by motorized raft across Lake Union in the middle of winter. These photographs are credited to Phil Webber, who braved the weather to document the moving process. (Both, courtesy of the FHA.)

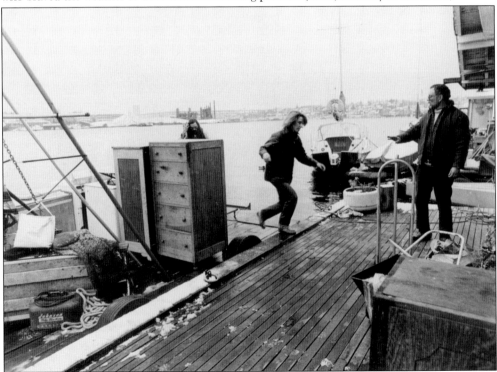

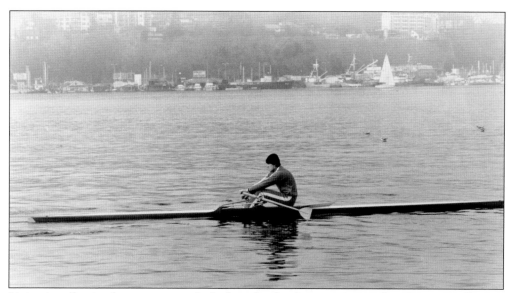

Living in a floating home comes with the benefit of a close community, but there are still many opportunities to be alone. Paddling around on the water can be a great time for relaxation as well as a chance to see the homes from the water. This unidentified man rowing on Lake Union was photographed by Jonathan Ezekiel in 1980. (Courtesy of the FHA.)

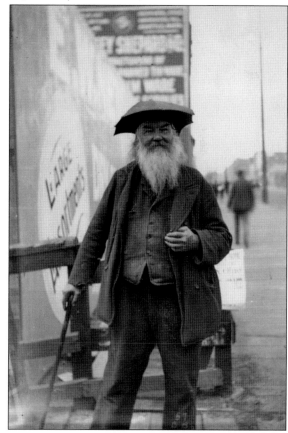

The distinct individuals who have lived in houseboats are legendary within the community. Robert Patten was an early member of the houseboat community known fondly as "The Umbrella Man." He is photographed here around 1910. A journalist working for the *Seattle Times* started using a caricature of Patten and his distinctive headwear to deliver the weather forecast. (Courtesy of the Museum of History & Industry, Portraits Collection, 2002.50.88.)

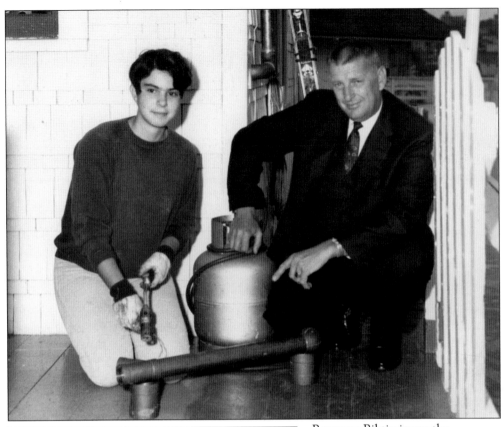

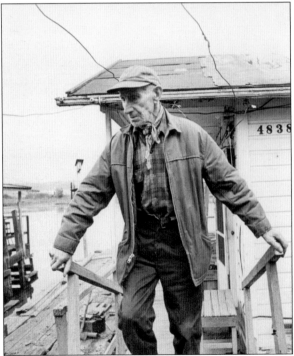

Roxanne Biktimir was the community's youngest home plumber. Roxanne is shown here at age 16 with city inspector Ed Dressell in 1967. She installed the family's plumbing system in her home at 2822 Boyer East, an event that set an example for others in the community and got her name printed in the FHA newsletter that year. (Courtesy of the FHA.)

Norwegian immigrant Fred Strom is shown in front of his floating home on the Duwamish River, which he refused to leave despite eviction efforts by the Port of Seattle. For years, the port planned to expand industry farther up the Duwamish, and all floating homes except for Strom's were removed. The photograph was taken in 1977 by Matt Rose for the *Seattle Sun*. (Courtesy of the FHA.)

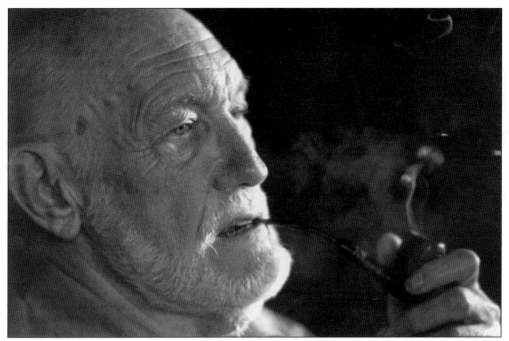

An icon of the Seattle floating homes community, Terry Pettus was a journalist who moved into the community after being persecuted for his beliefs during the McCarthy era. Terry's leadership in the founding and activism of the Floating Homes Association will be discussed further in chapter four. This photograph was taken by Howard Droker during his research on the community in 1977. (Courtesy of Howard Droker.)

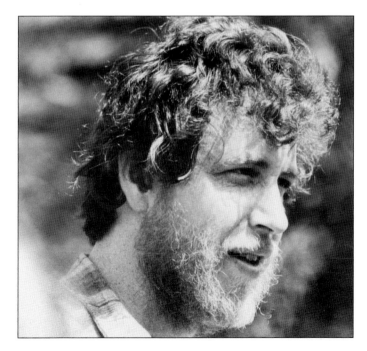

Another individual who has been critical in organizing and leading the floating homes community is Bill Keasler, photographed in 1980 by Phil Webber. Bill served as president of the Floating Homes Association for almost 30 years, acting as the public face of the community and an enthusiastic advocate for the concerns of others. Bill remains involved with the community, and the FHA office was recently dedicated as Keasler Cottage in his honor. (Courtesy of the FHA.)

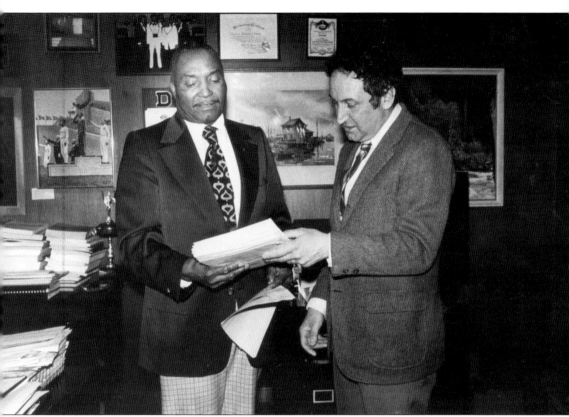

Dick Wagner, well known in Seattle as the founder and executive director of the Center for Wooden Boats, has for years been an active member of the floating homes community. He is shown here in 1977 during his tenure as president of the FHA discussing the proposed Equity Ordinance with Sam Smith, president of the city council. The Equity Ordinance was written to protect floating home owners who rented their moorage space from excessive increases in rent and unwarranted evictions. This ordinance was hotly debated and revised multiple times. The community eventually found that the best solution was to support home owners to purchase the docks, managing their own maintenance and finances as a cooperative or condominium. (Photograph by Jonathan Ezekiel; courtesy of the FHA.)

The Center for Wooden Boats began in 1968 out of the floating home owned by Dick Wagner; it is known to this day as the Old Boathouse. The Old Boathouse was relocated from Lake Washington and is the same structure as the house shown in the 1912 photograph on page 12 of this book. An assortment of wooden boats surrounds the floating home in Westlake, as shown in these photographs taken in 1974 by Marty Loken. Dick Wagner's hobby of working with wooden boats and his passion for education became his work. The Center for Wooden Boats on South Lake Union was officially established in 1983. (Both, courtesy of Dick Wagner.)

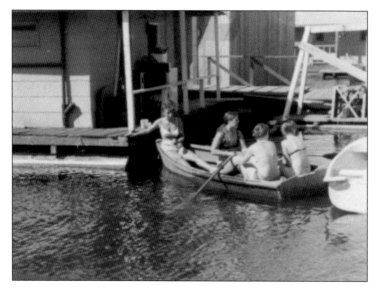

Boating has long been a convenient way to move around the floating homes and adds other opportunities for interaction among neighbors. This group of young women paddles around in bathing suits in the 1950s, enjoying a warm summer day. This photograph is from the collection of former community resident Ray Woods. (Courtesy of Jann McFarland.)

The Dime-A-Dance Hall floating home was once used as a parlor for entertaining men who paid 10¢ for a dance and could engage in other illicit activities for more money. The structure was relocated from the Leschi ferry terminal in the 1920s to a dock on Lake Union. The home still has the original wood floor and leaded glass windows. The original wallpaper was red burlap. (Courtesy of the FHA.)

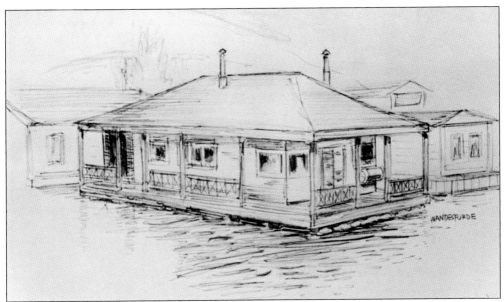

The Hostess House floating home, which is now located on Portage Bay, was reportedly built as a comfort station—a rest stop for visitors—at the 1909 Alaska-Yukon-Pacific Exposition. This sketch by dock owner and artist Jim Wandesforde depicts the fine craft of the historic floating home that is now in need of significant repairs. (Courtesy of the FHA.)

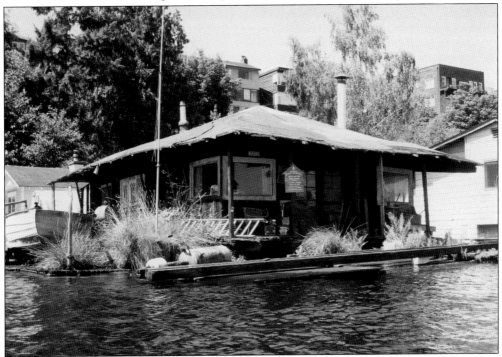

The float and roof structure on the Hostess House are in need of repair, but the interior wood paneling and fireplace are still intact. Owner Ken Kennedy has unrealized plans to repair the structure and hopes that the future owner will preserve this historic floating home instead of replacing it with a new one. (Author's collection.)

A book on the Seattle floating homes would be incomplete without mention of the film *Sleepless in Seattle* and its floating-home movie set. For anyone not familiar with the film released in 1993, the main character, played by Tom Hanks, lives in a Seattle floating home as a bachelor with his son. The film played an undeniable role in the development of a romanticized perception of life on floating homes. This perception in turn impacted real estate values as floating homes became a more desirable commodity. An interest inspired by the film led the current owners of the famous home, Jim Healy and Loretta Metcalf, to look at floating homes when they moved to Seattle. (Both, courtesy of Jim Healy and Loretta Metcalf.)

Jim and Loretta moved into the home after the film was completed and enjoy the fact that their home has become a main Seattle attraction for visitors. The *Sleepless in Seattle* bench that was featured for a scene in the film is located at the end of the dock adjacent to the floating home and attracts an annual pilgrimage by visitors from around the world. Curious visitors come by kayak, pleasure craft, the amphibious Duck Tours, and aboard the Argosy boat tour, which gave them a bottle of champagne as a wedding gift in 1994. Fortunately, the current owners do not mind having their home be a tourism icon ogled from both land and water as long as their personal space is respected. Although the docks are private residential property, many visitors take photographs on the bench, as it is a place to enjoy the view of both the lake and the floating homes. (Courtesy of Jim Healy and Loretta Metcalf.)

The Archipelago of Tui Tui is the name of a small dock of floating homes established as an independent nation in 1985. The current owners decided to declare the dock an independent nation after they succeeded in purchasing it from its former owner following years of disputes over a planned remodel. The end floating home, Grande Tui, is custom designed to reflect the semiotics of the nation and distinct tastes of the owners. (Author's collection.)

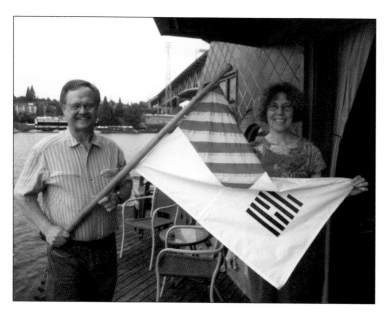

Floating homeowners and leaders of the nation of Tui Tui are Co-Tyee Dogfish (Robby Rudine) and Co-Tyee Dragonfly (Janet Yoder). They proudly display the flag of the nation of Tui Tui. A tourist visa is required for entry to Tui Tui, although fluency in the local Lushootseed language is not essential. (Author's collection.)

Four

SEATTLE'S FLOATING HOMES ASSOCIATION

Organizing a group of individuals to protect communal interests was a challenge for the floating homes community, but the culture of social activism and engagement has become a significant community asset. After a few precursors came and went, the Floating Homes Association (FHA) was founded in 1962 as a nonprofit organization comprised of members from the floating homes community and affiliated organizations. The FHA has been critical in negotiating with the City of Seattle over regulations, engaging with other waterfront communities, and representing the floating homes in public discourse.

The first attempt at organizing the community was in 1922 when the Houseboat & Home Protective League was founded to defend the large population of working-class residents living in what were then inexpensive floating houses. Upland residents considered the houseboats undesirable and tried to argue that they polluted the water with their sewage. However, the community won an early victory when it was revealed that the City of Seattle was dumping its own sewage into the waters. In the late 1930s, the Waterfront Improvement Club led another round of eviction efforts on Lake Washington based upon the issue of sewage. In the early 1950s, the Houseboat Owners Association fought eviction efforts by upland residents, but this group disbanded after initial houseboat legislation was passed in 1957. It was in the early 1960s that the self-titled houseboaters determined to permanently organize in order to survive. At this time, the community adopted the term *floating homes* to distinguished themselves from other houseboats.

The Floating Homes Association is now the public face of the insular community and plays a vital role for this historically controversial group. The FHA board meets each month and holds an annual meeting to socialize and hear from guest speakers on major issues. The FHA engages the greater public through floating home tours, sales through its Houseboatique, participation in citywide events, and dialogue with other communities. The presidents of the Floating Homes Association have been George Neale (1962–1964), Esther Carhart (1964–1966), Ken Kennedy (1966–1968), Bob Brown (1968–1969), Clara Kennedy (1969–1972), John Southern (1972–1974), Dick Wagner (1974–1978), Julie North (1978–1981), and Bill Keasler (1981–2010). Marty Greer is currently president.

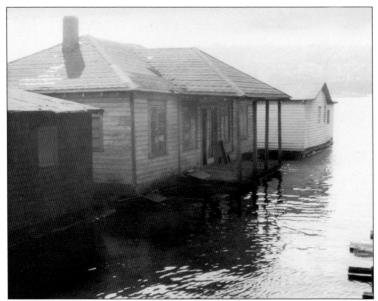

This 1964 photograph of the no-longer-existing Adamic moorage shows the simple and rather dilapidated character of the floating homes at that time. Before connecting to the sewers, the floating homes were a less glamorous place to live than they are today. (Courtesy of the FHA.)

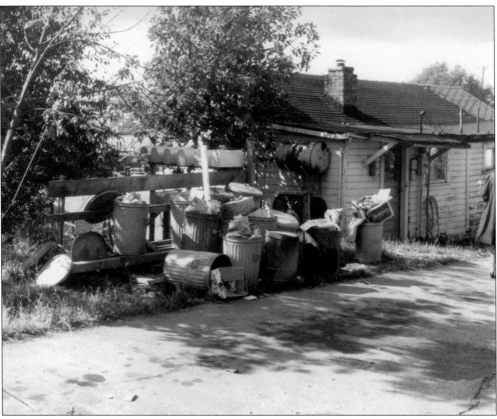

Scenes such as the haphazard conditions of these garbage cans used by the floating homes at Roanoke Reef only fueled eviction efforts by upland residents. The FHA started a Beautification Committee in the early 1960s that addressed issues in the community, such as waste collection and street presence. This image was taken in 1964. (Courtesy of the FHA.)

FLOATING HOMES ASSOCIATION, INC.

2017 FAIRVIEW EAST • SEATTLE 2, WASHINGTON • EA 3-1629

NEWS LETTER

NUMBER 1 MARCH 19, 1963

MEMBERSHIP MEETING THURSDAY, MARCH 28

Place: Room 1 (first floor) West Queen Anne Field House, First West & Howe Sts.

Time: Meeting starts promptly at 7:30 p.m. Adjournment promptly at 10 p.m.

The Program Features Four Important Information Reports

1. "Assessments of Houseboats For The 1964 Tax Rolls" by Mr.
 Thomas Walker, Deputy King County Assessor.

2. "A Proposal For The Rezoning of Lake Union" by Mr. Jack
 Robertson, Chairman Lake Union Study Committee of the
 Seattle Citizens' Planning Council.

3. "Our Clean-Up, Paint-Up, Fix-Up Campaign" by Bob Eyre,
 Chairman, Beautification Committee.

4. "The Status of the Proposed Lake Union-Portage Bay Trunk
 Sewer". Special Executive Committee report.

Proposed Amendment To By-Laws: That Article 1, Section 5, entitled "Board of Directors"
be amended to give the Executive Committee authority to fill vacancies on the Board from
the respective moorages, subject to the approval of the membership.

All Interested Persons Are Invited to Attend

* * * * *

MEMBERSHIP ADOPTS FIVE-POINT ACTION PROGRAM: A five-point action program was approved,
permanent officers elected and by-laws adopted by some 200 members at the first annual
business meeting Feb. 15. The program was unanimously approved following a comprehensive
report on significant developments during the past 18 months given by President George
Neale.

The first newsletter of the Floating Homes Association, published on March 19, 1963, brought many issues to the attention of floating home residents for the first time. Topics included the following: the announcement of the first annual meeting, an FHA membership enrollment drive, a campaign for beautification efforts to improve the public impression of the community, and a request for moorages for 18 floating homes that had recently been evicted. Another major issue was the need for comprehensive regulation repealing the 1953 ordinance requiring 40 feet of open water between homes. Also, a proposal for rezoning of Lake Union—rezoned in 1957 to have 85 percent of its shoreline dedicated for commercial or industrial use—was made to push for more residential zoning. The community worked with the city council and local government for decades to resolve these issues, and now most of the floating homes moorages are in areas zoned for single-family residences. The code has been updated to require only 10 feet between homes. The FHA newsletter, now called *The Waterlog*, is still published several times a year. (Courtesy of the FHA.)

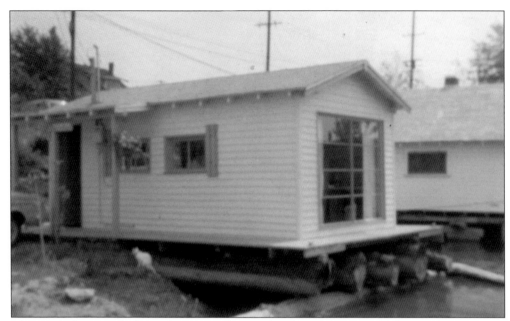

This 1965 photograph shows the FHA office newly adapted from an old floating home on the east shore of Lake Union. The less than 250-square-foot office, recently dedicated to former FHA president Bill Keasler, is located at 2329 Fairview Avenue East. It is staffed part-time, with additional support from board members. (Courtesy of the FHA.)

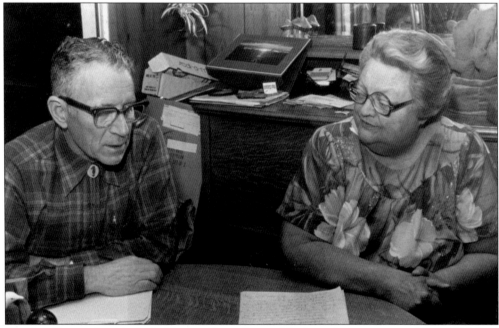

Floating Homes Association's first president George Neale and first secretary Muriel Ecklund got together in 1979 to share stories from the early days of the FHA. Neale's efforts to relocate around 100 houseboats evicted for the construction of the State Route 520 Bridge resulted in the founding of the Floating Homes Association in 1962. The photograph was taken by Jonathan Ezekiel. (Courtesy of the FHA.)

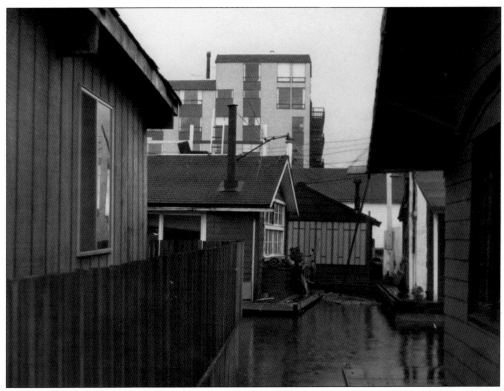

Land use and zoning on Lake Union have caused conflicts in the past between the floating homes and other lake users. The Union Harbor Condos, constructed in 1968 on Fairview Avenue East, came as a shock to floating homes residents who suddenly found themselves overshadowed by the waterfront high-rise. This 1969 photograph taken from a dock north of the condos shows the visual impact of the development. (Courtesy of the FHA.)

The Floating Homes Association launched a legal battle against the Union Harbor Condos as soon as construction began, but it was too late to stop the development and the condos still exist today. However, waterfront high-rise developments are no longer allowed on Lake Union, since they create an overdeveloped shoreline and significantly obstruct views. (Author's collection.)

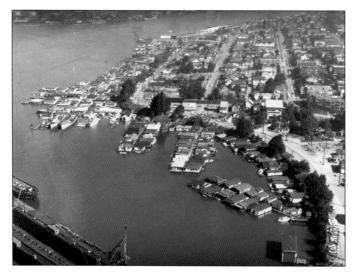

Floating homes in a moorage that used to exist on Fairview Avenue East between Newton and Blaine Streets are documented in this aerial photograph from 1962. This photograph was taken before evictions were issued to make way for the construction of the research facility for the National Oceanic and Atmospheric Administration (NOAA). (Courtesy of the Seattle Municipal Archives, 63792.)

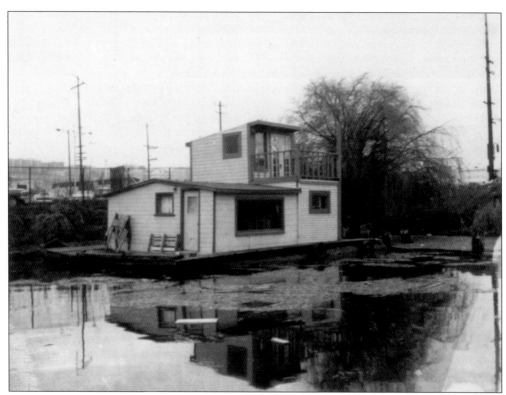

At the same time that large over-water uses were being debated, some floating homes were finding they were also unwelcome. This floating home belonging to Robert Weppner, photographed by John Southern in 1979, was abandoned to a state waterway after being evicted from its moorage on Fairview Avenue East. Robert sold the home, once appraised at $12,000, as salvage for $1 instead of paying towing fees. (Courtesy of the FHA.)

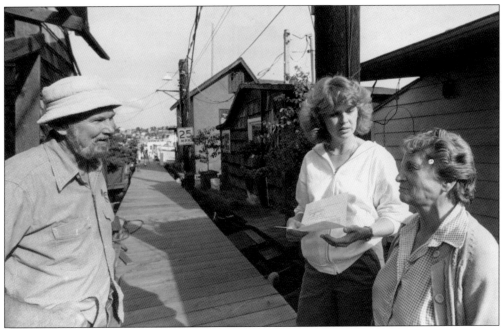

Eviction notices became less common as docks began to transition to cooperative or condo ownership models. Floating home residents, from left to right, Paul Thomas, Carol Simanis, and Barbara Nelson were not so fortunate and received eviction notices in 1983 from their dock owner. The photograph was taken by Phil Webber. (Courtesy of the FHA.)

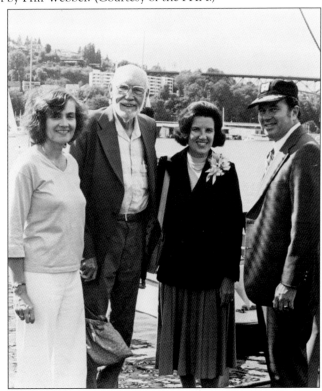

FHA president Julie North and executive secretary Terry Pettus meet with Seattle's police chief Fitzsimmons and his wife in 1979. During the Prohibition Era, police raided houseboats for bootlegging. To conceal evidence, bottles were dropped through trap doors in the floor that can still be found in older homes. Relations with law enforcement have vastly improved as floating homes have been legally accepted. (Courtesy of the FHA.)

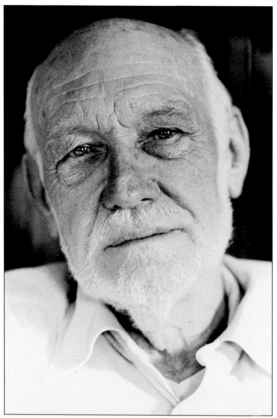

Terry Pettus (1904–1984), a retired journalist, led many battles to save Lake Union's shorelines and contributed immeasurably to the long-term viability of the floating homes community. This photograph, taken by former resident Anita Coolidge, is one of the most strikingly personal and highly reproduced images of Terry. (Courtesy of Anita Coolidge.)

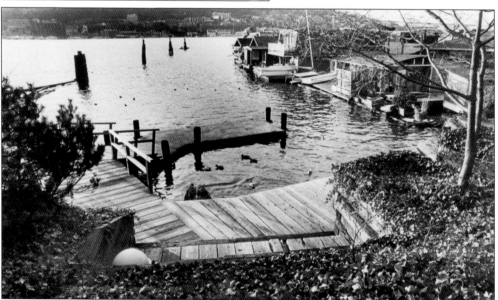

Terry Pettus Park was founded in 1986 to honor Terry with a public space that provides a view of both Lake Union and the floating homes. The park on Fairview Avenue East at East Newton Street was officially dedicated at the Floating Homes Association's 25th Anniversary Jubilee. (Photograph taken by Phil Webber; courtesy of the FHA.)

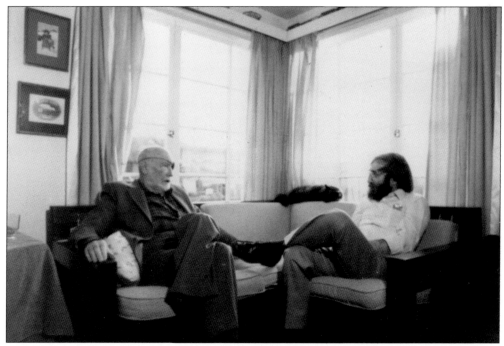

In this photograph, Jim Knight and Terry Pettus chat together in the early 1980s. Jim Knight was a longtime active resident in the floating homes community. Terry, although he never served as president, served as the executive secretary of the FHA and became an icon of the community. (Courtesy of the FHA.)

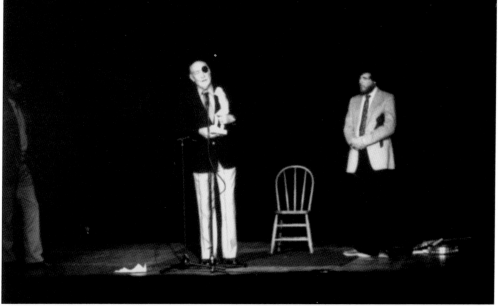

A concert featuring musician Pete Seeger and honoring Terry Pettus for his service to the floating homes community was held in 1982. More than 1,400 came to see the sold-out show held at the Moore Theater. In this photograph, Terry gives a speech after receiving an award from FHA president Bill Keasler. (Courtesy of the FHA.)

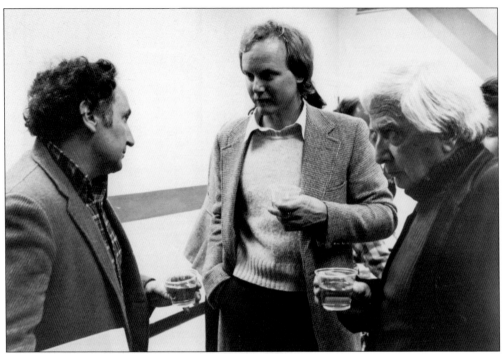

The FHA Annual Meeting has always been an opportunity for the community to engage with representatives from the city and outside organizations. At this meeting in the late 1970s, FHA president Dick Wagner (left) chats with Rob Anglin and an unidentified guest. Anglin led a City of Seattle project to survey and inventory floating homes. The project was never completed. (Photograph by Jonathan Ezekiel; courtesy of the FHA.)

This 1981 photograph by Jonathan Ezekiel captures the newly elected FHA president Bill Keasler in his first days in action at the office. Bill moved into the community in 1970 and went on to serve as president for almost 30 years. He led the community through its transition to the relative stability it enjoys today. (Courtesy of the FHA.)

City council member Paul Kraabel served from 1975 to 1991 and was a dedicated advocate for the floating homes community. Paul was involved in several major legislative responses to the community, including the evolution of the Equity Ordinance to protect the rights of floating home owners. Paul Kraabel now lives in the floating homes community. This photograph was taken by Jonathan Ezekiel in 1980. (Courtesy of the FHA.)

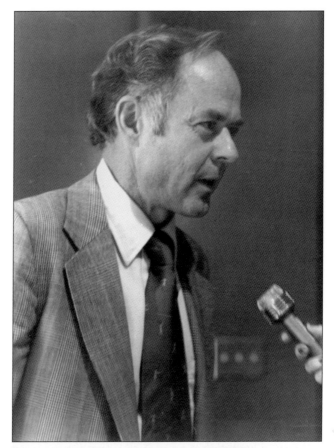

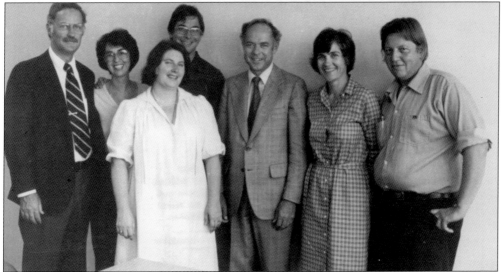

Members of the floating homes community pose with Councilman Kraabel after a city council hearing in 1981 on the Equity Ordinance that went well. Pictured from left to right are Jack MacIntyre, Dixie Pintler, unidentified, Todd Warmington, Paul Kraabel, Julie North, and Jonathan Ezekiel. (Courtesy of the FHA.)

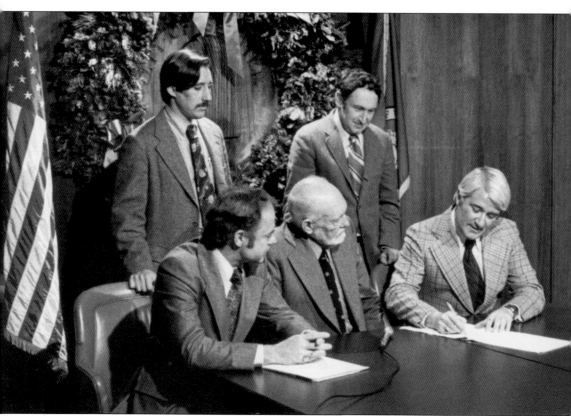

Mayor Wes Uhlman (seated at right) signs the revised Equity Ordinance in 1977 with onlookers FHA attorney Bruce Corker (standing left), FHA president Dick Wagner (standing right), Councilman Paul Kraabel (seated left), and FHA administrative secretary Terry Pettus (seated at center). The Equity Ordinance protected floating home owners who did not own their moorage from unreasonable increases in rent or notice of eviction. In a letter from November 8, 1972, Mayor Uhlman wrote to the Floating Homes Association: "Ecologists tell us that it is in complexity and diversity that environments find the strength to withstand new forces and unexpected changes. Perhaps this explains why Lake Union and the Lake Union community have remained one of Seattle's most unique and priceless natural amenities." Mayor Uhlman applied this ecological perspective to the manmade environment on Lake Union as well and supported a diversity of uses that included the floating homes. The photograph was taken by Jonathan Ezekiel. (Courtesy of the FHA.)

Seattle mayor Charles Royer replaced Wes Uhlman in 1977 but proved willing to work with the floating homes community as well. Royer came to speak at the FHA annual meeting in 1979. Many city officials were surprised to see how much smaller the community of floating homes was actually compared to their perception based on the correspondence efforts led by the FHA. (Courtesy of the FHA.)

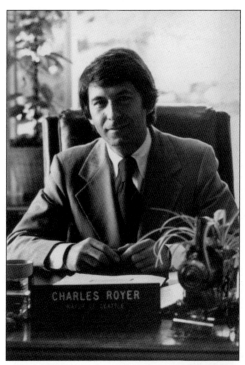

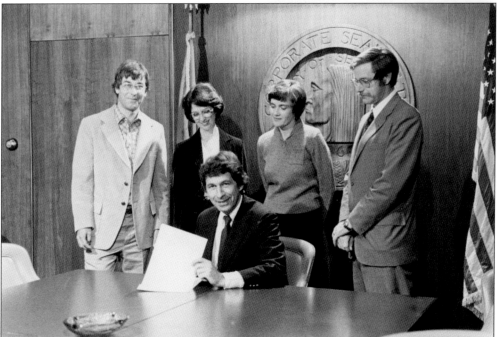

Charles Royer (seated) served three terms as mayor until 1990. He is photographed here with floating homes community members, from left to right, Todd Warmington, Dixie Pintler, Julie North, and Larry Ransom. Royer issued a proclamation of Terry Pettus Day on March 7, 1982, showing his support for the community's efforts. The photograph was taken by Jonathan Ezekiel in 1980. (Courtesy of the FHA.)

Barbara Seeber was one of the many floating homes residents who testified over the hardships encountered in dealing with rent increases or evictions by moorage owners. Here, she is photographed by Phil Webber at a city council hearing in 1983 with her son John. (Courtesy of the FHA.)

Many floating home owners went into legal proceedings with moorage owners over the years. Here, R.E. Skarperud serves as the fact-finder on a dispute, demonstrating how many of the homes on the disputed dock have been granted a legal nonconforming designation, despite their location beyond the construction limit line. The photograph was taken by Jonathan Ezekiel in 1980. (Courtesy of the FHA.)

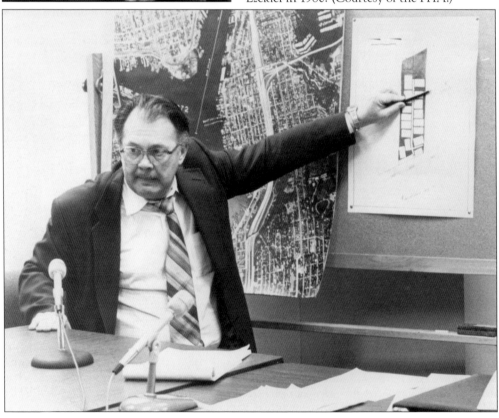

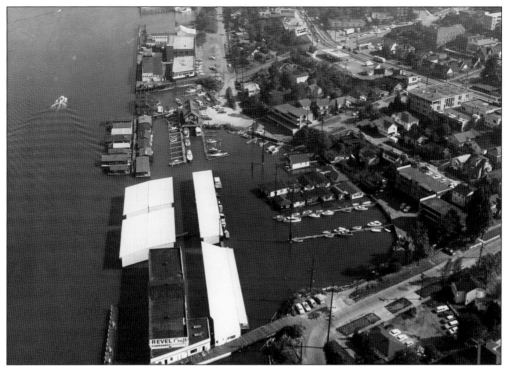

This 1962 aerial photograph shows the shared occupation of Mallard Cove by marinas, maritime industrial uses, and moorages for floating homes. The larger structures at the base of the image were replaced by the controversial Roanoke apartment project, which was finally defeated and replaced with a floating home moorage that exists today, known as Roanoke Reef. (Courtesy of the Seattle Municipal Archives, 63796.)

Proposed construction of an overwater apartment building at the base of Roanoke Street launched a legal battle that lasted throughout the 1970s. Today, no large overwater construction is allowed on Lake Union, but the Union Harbor condos and AGC building exist as reminders of what the urban lake should not become. This photograph of the concrete base was taken in 1980 by Jonathan Ezekiel, just before it was demolished. (Courtesy of the FHA.)

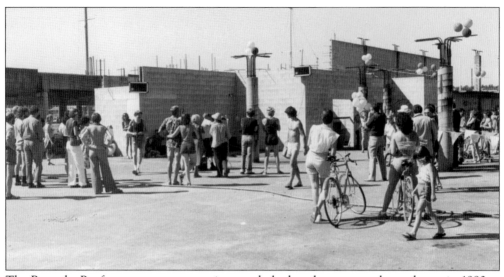

The Roanoke Reef apartment construction was halted at the concrete base, shown in 1980 at the Demolition Party, which celebrated the victorious effort to prevent the planned domination of the waterfront. Crowds gathered to walk the concrete pier before demolition. The photograph was taken by Jonathan Ezekiel. (Courtesy of the FHA.)

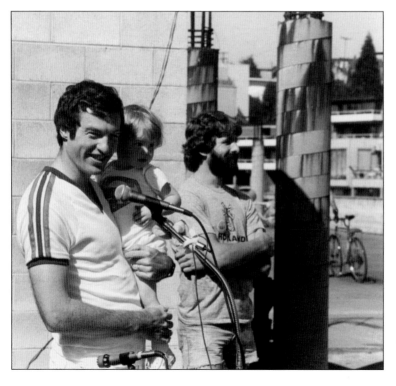

City Attorney Doug Jewett was involved in the battle to stop the apartment building at Roanoke from setting a precedent for future shoreline development shortly after he was elected to the position in late 1977. Jewett, in casual attire for the community celebration, gives a speech while holding his child. The photograph was taken by Jonathan Ezekiel in 1980. (Courtesy of the FHA.)

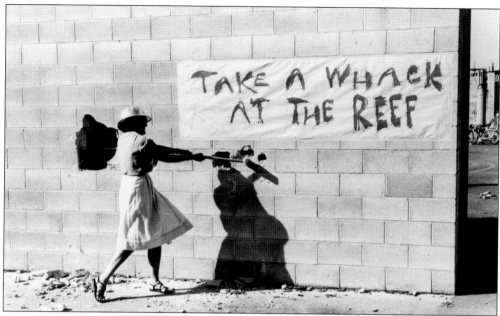

One of the most iconic photographs from the Roanoke Reef apartment controversy is this image of developer Lucille Flanagan exercising her right to "take a whack at the reef." The floating homes community was certainly not the only group in opposition to the large-scale overwater development. The photograph was taken by Jonathan Ezekiel in 1980. (Courtesy of the FHA.)

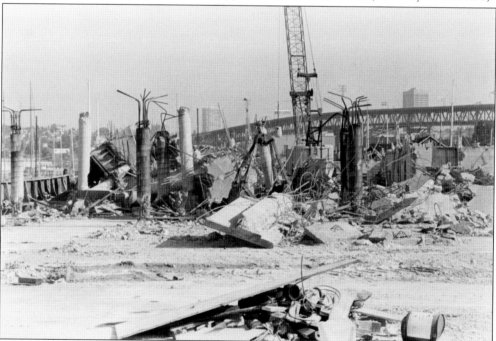

This photograph shows construction debris during the Roanoke Reef demolition. Rubble from the apartment base was sold for $1 to try to cover some of the legal expenses accrued during the near decade-long battle to stop the development. The photograph was taken by Jonathan Ezekiel in 1980. (Courtesy of the FHA.)

The Floating Homes Association held its first auction in 1982. The community auctioned off food, services, and even weekend stays in a floating home to repay legal debts accrued in the 1970s. Here, auctioneer Jerry Toner excites the crowd. The photograph was taken by Phil Webber. (Courtesy of the FHA.)

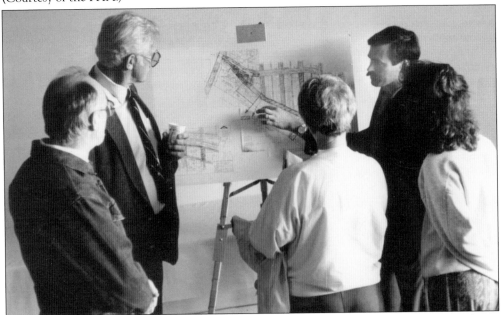

In addition to fighting development that threatened the character of the lake, the floating home community has been involved in various efforts to enhance or improve the shorelines of Lake Union and Portage Bay. Here, community members discuss the development of Fairview Avenue East as a "green street," a Seattle system for promoting pedestrian-friendly, landscaped roadways. (Courtesy of the FHA.)

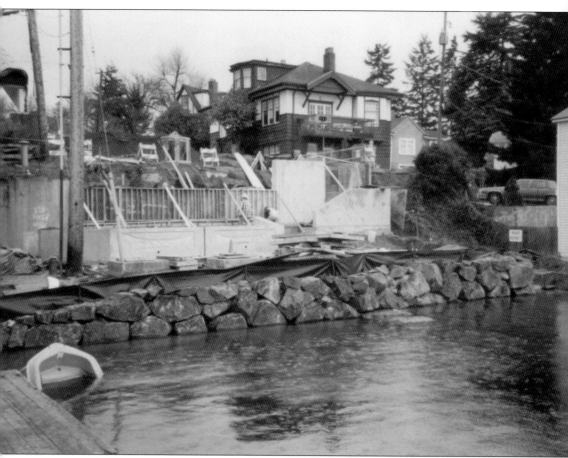

Floating homes were once moored at the ends of city streets in Seattle. However, in the mid-1970s, the city declared this land to be public property reserved for waterfront viewing and evicted all floating homes from these locations. Street-end parks began to appear soon after, such as this small park at the end of East Shelby Street. The park was significantly upgraded in the mid-1990s as part of a City of Seattle combined sewer overflow project. To distract from the ongoing issue of sewage overflow into Lake Union and Portage Bay, an artist was hired to make a memorial wall on the site. The memorial wall and park were dedicated to Cheshiahud, who lived there with his wife on one of the last Native American settlements in Seattle at the turn of the 20th century. (Courtesy of Mack Hopkins.)

The year 1981 marks the first Houseboat Tour, which has since been hosted every two years by the floating homes community. Tour guests were transported around Lake Union to the various floating homes by the *Islander*, a local charter boat. The photograph was taken by Jonathan Ezekiel. (Courtesy of the FHA.)

Riding aboard the *Islander* afforded tour guests a new perspective on floating homes from the water. Floating homes are a unique type of urban housing because their back porches are oriented towards the street, while their front porches often face the water. The photograph was taken by Phil Webber in 1981. (Courtesy of the FHA.)

The tour of floating homes is a unique opportunity for curious locals and visitors to Seattle to get down onto the normally private docks. Although the floating homes are the main attraction, many tour guests are also impressed by the character of the different docks. The photograph was taken by Jonathan Ezekiel. (Courtesy of the FHA.)

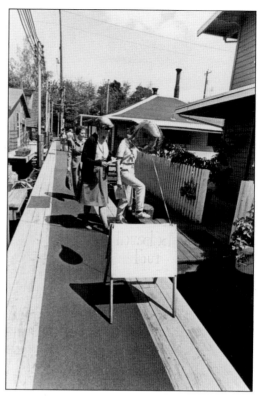

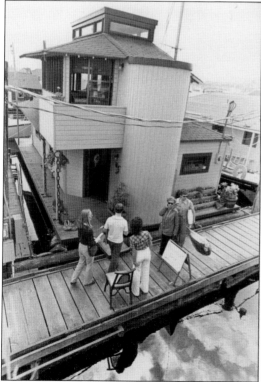

Guests on the first tour of floating homes in 1981 might not have realized how fortunate they were to get tickets to this event; the tour has consistently sold out every year it has been held. The tour has become an important event, providing critical financial support to the community and generating positive public interest. The photograph was taken by Jonathan Ezekiel. (Courtesy of the FHA.)

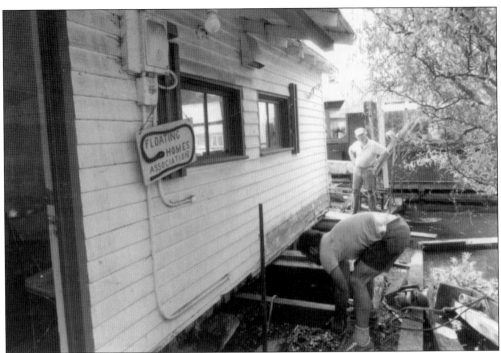

Residents adept at do-it-yourself projects in their own homes apply those same skills—as volunteers—to the FHA office. Art "the Stringer Man" Holder works with Joe Hall to replace the stringers on the office after almost 20 years of use. Stringer replacement requires lifting up the house structure, removing rotted beams, and then maneuvering new beams under it. Although the FHA office is smaller than most floating homes, the job remains challenging. A similar effort was coordinated in 2011 to repaint the FHA office for its dedication as Keasler Cottage, in honor of former FHA president Bill Keasler. These photographs were taken by Caryl Keasler in 1983. (Both, courtesy of the FHA.)

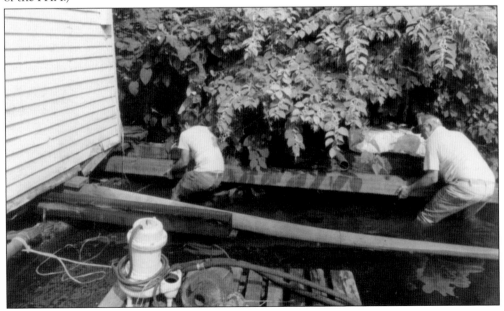

In 1987, the Floating Homes Association celebrated its 25th anniversary with a cake, shown here with the original FHA logo frosted onto it. The community celebrated throughout the year at the annual meeting, floating homes tour, and the 25th Anniversary Jubilee and Street Fair. The FHA celebrates its 50th anniversary in 2012. (Courtesy of the FHA.)

This photograph shows City Councilman Jim Street joining in the festivities for the FHA's 25th anniversary. Jim Street served on the city council from 1984 to 1995 and promoted the development of the Department of Neighborhoods. Because of his investment in neighborhoods and urban planning, Jim Street was a supporter of the floating homes community. (Courtesy of the FHA.)

In addition to celebrating 25 years of community organization, the Floating Homes Association took the opportunity in 1987 to formally dedicate Terry Pettus Park with a public ceremony. During this event, speakers included Paul Kraabel, Mayor Charles Royer, and FHA president Bill Keasler. This photograph was taken by Phil Webber. (Courtesy of the FHA.)

The banjo club, shown performing in this photograph, was one of the many forms of entertainment during the 25th Anniversary Jubilee and Street Fair. Live music, food, floating home tours, friendly conversation, and sunshine were all integral to the success of the celebration. (Courtesy of the FHA.)

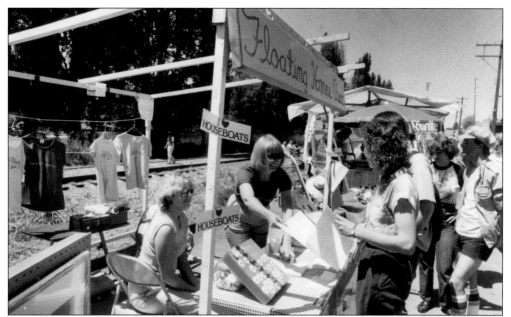

Rhonda Webber and Sheri Lockwood work at the FHA booth at the Fremont Fair in 1987. The Houseboatique, one of the community's many puns, creates a positive public presence for the community while selling floating homes–related merchandise. Creative community members have designed canvas bags, posters, clothing, and even the *Floating Kitchens* cookbook. The photograph was taken by Phil Webber. (Courtesy of the FHA.)

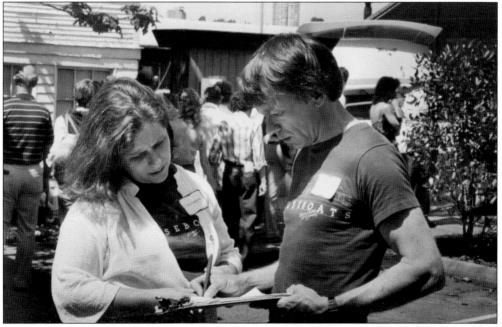

Volunteer residents Lois Loontjens and Tom Susor coordinate during one of the floating homes tours in the early 1980s. Tom Susor and his wife, Susan, built their home on the University dock on the north side of Portage Bay and have both been active volunteers in the floating homes community. (Courtesy of the FHA.)

Gov. Chris Gregoire, seated in front, signed a bill into law on April 29, 2011, which allows for the "continued use, improvement and replacement" of floating homes. Having this bill signed was critical in ensuring long-term vitality for the community. Prior to this law, there had been concern that code restrictions would prevent the maintenance of older homes that did not comply with all parts of the current code, such as the required 10-foot setback between homes. Pictured in the photograph are, from left to right, Tom Clingman from the Department of Ecology; Nick Federici, an FHA lobbyist; and Lake Union floating homes residents, including FHA president Marty Greer, board member Amalia Walton with her daughter Lilian, Lon Marie Walton, and Melissa Ahlers. The photograph was taken by staff for the Washington State House of Representatives. (Courtesy of the FHA.)

Five

CHANGES ON THE DOCKS

On houseboat docks during the Prohibition Era, bootlegging parties, artistic gatherings, and risqué businesses, such as the Dime-a-Dance Hall, might have been part of an average day. Newspaper clippings and accounts passed down through the community tell of wild parties, police raids, and even a murder or two over the years. Concurrently, photographs of children visiting their grandparents and family life illustrate the complexity of the community character. Photographs from the 1940s through the 1960s reflect the working-class appearance and lack of order that attracted criticism from upland neighbors. However, the floating homes community in recent decades has experienced changes that have also shaped the greater city of Seattle, including gentrification and real estate price escalation. A visit to the docks today can paint quite a different picture of life on the docks, one that is starting to lack the eclectic character and strong sense of community that has always characterized the floating homes community.

The docks have traditionally been an extension of the home for all residents. The docks provided access to the front doors of floating homes as well as shared spaces that stitched the community together. Talking with many of the longtime residents of the community reveals a sense of loss as these bonds of community diminish. While traditionally homes were occupied for decades by the same owners, turnover and rentals are now more common, which has changed the community significantly over the past few decades. In addition, newer homes are often designed to focus on the water and views, with very little engagement with rest of the community on the dock.

While change in ownership structure and architecture may alter the use of these community dock spaces, the communal dock will always serve as the one aspect of floating home life that makes it different from other forms of residential development. The vitality of the floating homes community as a unique urban neighborhood will continue to depend on the strength of the sense of community shared by residents living on the docks.

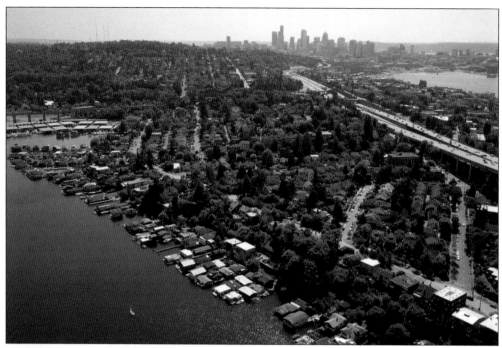

An aerial photograph taken over Portage Bay, with Lake Union and downtown Seattle in the background, shows the variety of size and organization of the floating home docks. A dock may consist of a single house or twenty floating homes. Many of the larger docks grew during evictions in other parts of the city over the years. The photograph was taken by Borislava Manolova. (Courtesy of Borislava Manolova.)

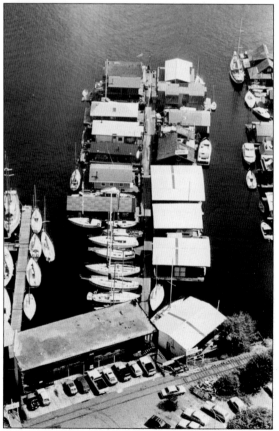

This dock in Westlake shows that docks may not be limited to only floating homes, but sometimes overlap with marina space. The shore use adjacent to floating home docks can be used as a public park, commercial use, land-based residences, or for parking lots. The photograph was taken in 1984 by Phil Webber. (Courtesy of the FHA.)

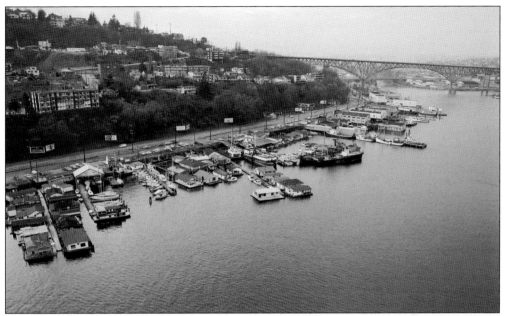

This aerial looking east over Lake Union towards the Westlake neighborhood was taken in 1966 by Bob Miller for the *Seattle Post-Intelligencer*. The houseboats are modest and densely packed between marine, aviation, and industrial uses. The floating homes in Westlake today are both larger and fewer in number, but there is still dense mix of uses in that area. (Courtesy of the Museum of History & Industry, Seattle, 1986.5.9756.)

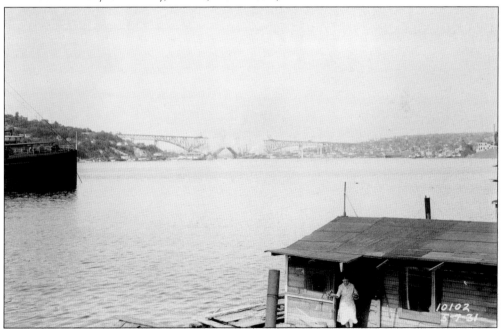

This photograph taken by the City of Seattle Engineering Department on May 7, 1931, captures both the construction of the Aurora Bridge and the working-class character of the houseboats. An unidentified woman stepped out of her home just at the photograph was being taken. (Courtesy of the Seattle Municipal Archives, 4935.)

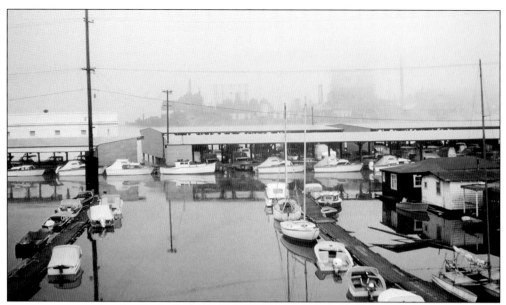

Overlapping uses on the shores of Lake Union include recreational, commercial, marine, and industrial, in addition to floating homes and other residential uses. Although recreation has become more common, Lake Union is still an example of a vibrant, mixed-use urban waterway. This 1959 photograph taken at the end of Edgar Street shows a dock of houseboats, a marina, and the gasification plant converted to Gasworks Park in 1975. (Courtesy of Michael Dederer.)

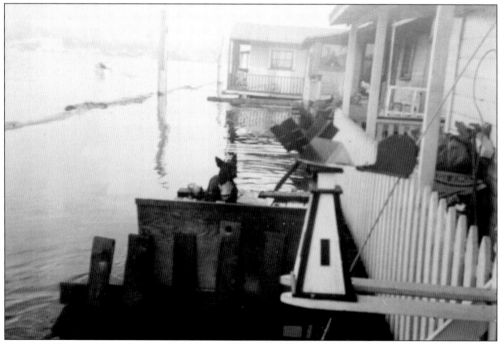

A view off the porch of the houseboat owned by Marie Williams Lucas at 2024 Westlake Avenue North during the late 1940s captures the simplicity of the houses and the working-class character. The white picket fence was put up to keep grandchildren and small dogs away from the open water. (Courtesy of Lynda Shelton.)

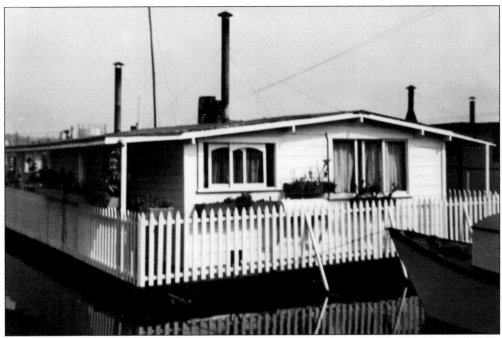

This photograph shows the houseboat owned by Marie Williams at 2024 Westlake Avenue North during the late 1940s. Her houseboat was evicted for a marina and was relocated to Fairview Avenue, to the site where houseboats were later evicted when the NOAA facility was established. Marie married David Lucas, and the couple settled farther north on Fairview Avenue in a second houseboat in the 1960s. (Courtesy of Lynda Shelton.)

Marie Williams Lucas, born in 1894, was the youngest of 14 children. Her family moved to Roslyn where her father worked in a coal mine. She eventually moved onto a houseboat in Seattle, which she later shared with husband David Lucas. This photograph of Marie was taken around 1960 in her home. (Courtesy of Lynda Shelton.)

As warehouse worker for Olypmia Beer, David Lucas never dressed up to go to work. This photograph taken in July 1957 shows David and Marie getting dressed up for a weekend outing. This was a regular weekend activity for the couple, and it included grandchildren Lynda and Bob when they came to visit. (Courtesy of Lynda Shelton.)

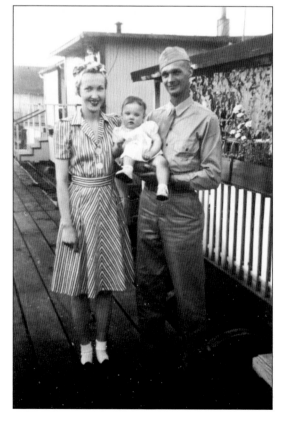

In this photograph taken July 1, 1944, Lynda Shelton is held by her parents, Joan and George Williams, down on a Westlake houseboat dock. That day, George left the family to serve in the military, and Joan began working. During the week, she would leave her children in the care of her mother, Marie, on her houseboat. (Courtesy of Lynda Shelton.)

When Lynda and her brother Bob went to visit their grandmother Marie, she would often dress them up and curl Lynda's hair. This photograph of Lynda in a fancy dress and shoes posing on the Westlake houseboat dock where her grandmother lived was taken in April 1948. (Courtesy of Lynda Shelton.)

David Lucas is photographed here outside of the houseboat that he and Marie shared in Westlake around 1950. Tragically, David drowned when he fell into the lake in 1960. He had been standing outside of the railing to water plants on their houseboat in Fairview. Marie remained in the home for several years after David's death but then sold it and moved onto land. (Courtesy of Lynda Shelton.)

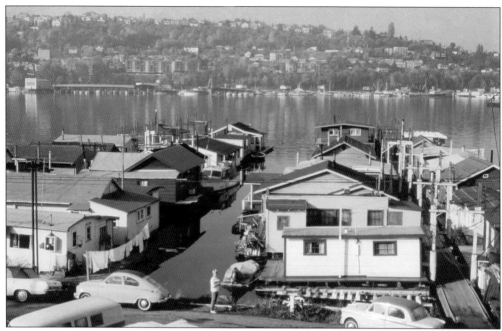

Barbara Donnette stands along the street near the docks of Tenas Chuck, where she still lives with her architect husband, Jim. This photograph from 1966 shows how much Fairview Avenue has changed over the years, from a dirt road to a paved one. In the 1960s, there were no trees along the water's edge, laundry was hung out to dry, and utilities lines were strung along posts above the dock. (Courtesy of Jim and Barbara Donnette.)

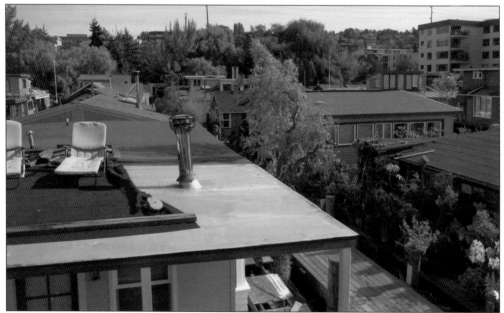

A 2010 view overlooking the Tenas Chuck moorage from the Donnette's home shows the condition of the docks today. Trees are now abundant along a paved Fairview Avenue. Since the moorage became cooperatively owned in 1995, dock improvements have been made, such as relocating all utilities under the dock. (Author's collection.)

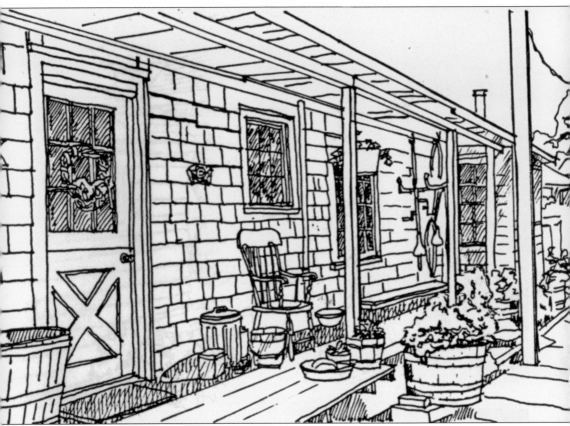

This sketch by Pamela Hidaka, drawn for her master of architecture thesis for the University of Washington, documents the front porch as a key feature of the floating homes community. In conducting research for her thesis, Pamela Hidaka spent months on the docks getting to know the community residents and architectural character. She closely observed patterns of architecture and of resident lifestyles in the floating homes community, which she linked together through her sketches and observations. She emphasized the human scale, intimacy, eclectic designs, and welcoming dock culture as distinct characteristics of the floating homes community. In conjunction with the presence of Dutch doors, bay windows, and outdoor seating, the front porch has long been an integral part of the physical features that support a welcoming culture in the floating homes community. (Courtesy of Pamela Hidaka.)

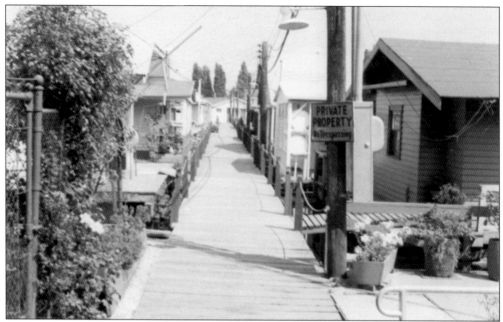

The dock owned by Helen McInnes, photographed in 1969, reveals a group of simple, single-story homes, characteristic of the community before the 1970s. Many of the homes have been significantly remodeled or rebuilt to become larger, two-story structures. Although some residents know each other quite well, there has been a trend towards fewer owner-occupied homes in recent years. (Courtesy of Mack Hopkins.)

Mack Hopkins puts his arm around "docklord" Helen McInnes after she brought him champagne and cigarettes for his birthday in 1981. Mack recalls that Helen was not the easiest person for people to get along with, but that she was a respectable and honest landlord, and their dock did not experience conflicts over rent and moorage rights as other docks did in the 1960s and 1970s. (Courtesy of Mack Hopkins.)

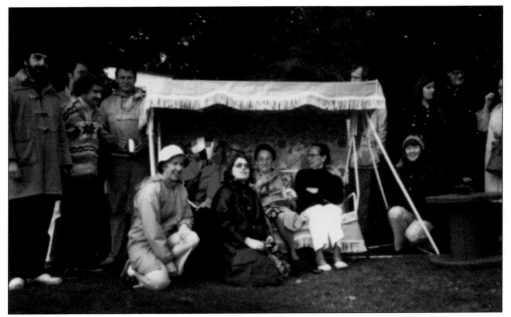

In 1981, the residents of the McInnes dock threw a party for Helen. They all pitched in money to buy her a lounge swing to use in her garden. Unfortunately, the swing collapsed right after they all gathered on it to take this photograph. Helen passed away in the early 1980s. In 1993, residents organized to cooperatively purchase the moorage as the Shelby Group. (Courtesy of Mack Hopkins.)

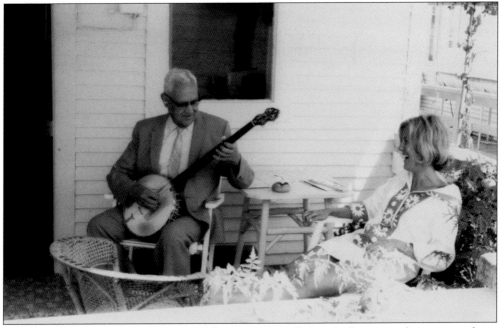

Mack Hopkins's father, Mack Senior, did not approve of his son's decision to live in a rundown floating home, yet he still came down to visit from time to time. On this visit in 1969, he covers up his dislike of the community and plays the banjo on the front porch for his son's friend Delphine, who in turn hides her dislike of the banjo. (Courtesy of Mack Hopkins.)

As in any dense urban neighborhood, life is not always peaceful on the docks in the floating homes community. Helen McInnes had an ongoing rivalry with neighboring docklord Jean Lunstead. The rivalry was intense enough that Jean built a spite dock with no functional use on her property bordering Helen's dock. The dock served as a notice to residents that there would be no community connection across the docks, although residents on the two docks had no hard feelings themselves. These photographs from the early 1970s show Jean Lunstead peering through the bushes on her property onto the McInnes dock and the spite dock built between their moorages. (Both, courtesy of Mack Hopkins.)

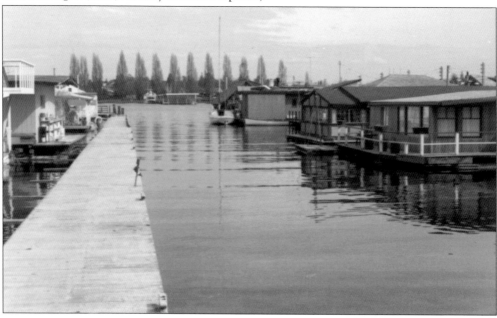

This moorage on the McInnes dock, photographed in 1969 (above) and 1999 (below), is an example of one of the major home rebuilds that reflect the changing character of the floating homes community. The new two-story house turns its back on the dock aside from a small strip of clerestory windows and a couple of small plants. Longtime residents, such as Mack Hopkins, have observed and even documented the changes on their docks. Although homes have been upgraded and the community enjoys the legal protection it sought for so long, many residents are at a loss for how to restore the sense of community that has always added charm to life on the docks. (Both, courtesy of Mack Hopkins.)

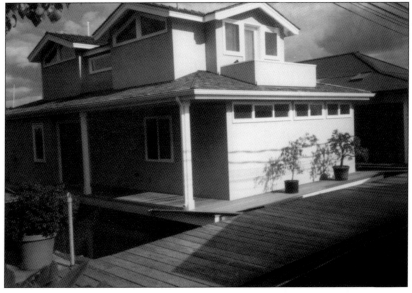

Jim Gray, who moved to Seattle from Texas to work for Boeing as an engineer, has been one of the resident musicians in the floating homes community since 1963. He plays many instruments, including the standup bass and the tuba. In the photograph at left, he shares his musical talents with other residents on the McInnes dock, including his neighbor Ann Schuh. Jim used to play at clubs around town and often played on the water aboard the *International Schooner*, as shown in the photograph below from Opening Day of yachting season around 1970. Jim Gray and Mack Hopkins have been neighbors since the 1960s and have lived on their dock longer than most of the other residents. (Both, courtesy of Mack Hopkins.)

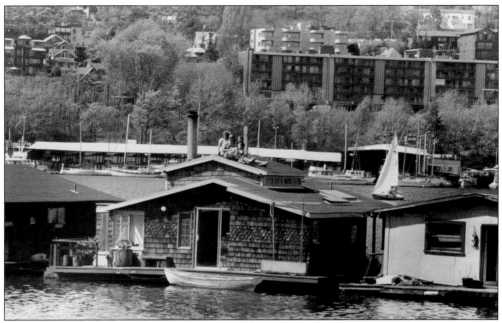

A rooftop of a floating home is a great place from which to watch events on Lake Union, such as the Duck Dodge races, described below. These floating home residents are taking advantage of having been "shuffled" out into Lake Union to enjoy the rooftop views from the middle of the lake. The photograph was taken by Phil Webber around 1980. (Courtesy of the FHA.)

Some traditions on the docks have not changed much over the years. For floating homes residents, watching the Duck Dodge has been a summertime tradition since the 1974. Sailboats of any size with any crew are invited out to Lake Union to race through a course while dodging the local ducks. The race serves as free entertainment for the community every Tuesday evening between May and October. (Courtesy of the FHA.)

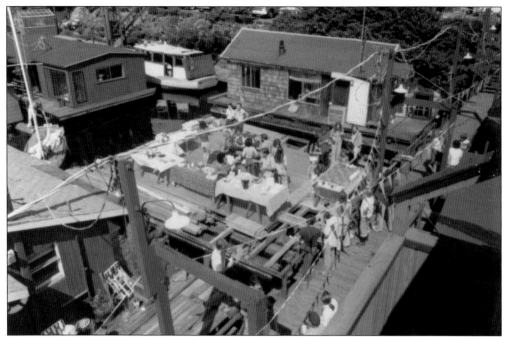

The group of docks on Fairview Avenue East known at the Log Foundation is a tight-knit community of residents despite being the largest cooperatively owned moorage in Seattle, at 52 homes. A dock party on the deck of a home about to be constructed is seen from above in this photograph from 1970. (Courtesy of Linda Knight.)

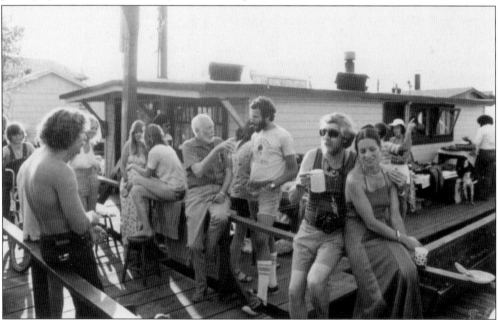

A traditional event that began on the Log Foundation docks in the early 1970s and took place annually for 25 years was the 2025 Fairview Avenue Luau and Pig Roast. This c. 1970 photograph shows residents gathering along the docks to enjoy food, drink, music, and each other. Such events have become less common on the docks in recent years. (Courtesy of Linda Knight.)

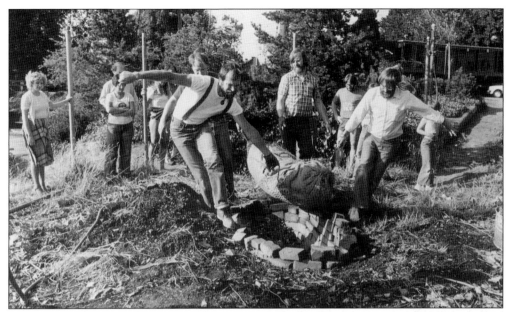

Roasting a pig in a pit for the 2025 luau was a tradition that everyone on the docks helped with. The men charged with carrying the pig in 1982 were, from left to right, Sid McFarland, Tom Haslett, Ed Dupras, and Jim Knight. This photograph was taken by Phil Webber in 1982. (Courtesy of the FHA.)

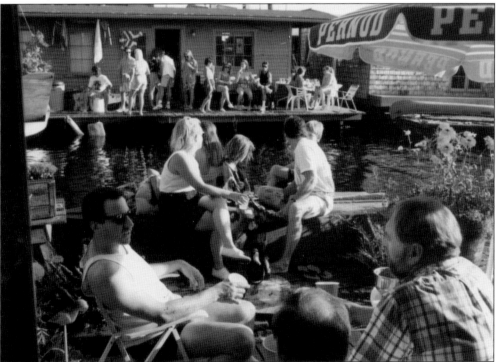

The 2025 Fairview Avenue Luau and Pig Roast was just another excuse for floating homes residents to sit on the docks to enjoy the summer sun. In this 1980s photograph, the party extends across the water to other homes on the Log Foundation docks. (Courtesy of Jann McFarland.)

Anita Coolidge holds her daughter Rachel during a luau in 1970. Although most children who grow up in the community learn to swim at a young age, it is not a bad idea for younger kids to wear life jackets, particularly when parents are busy enjoying a party. (Courtesy of Linda Knight.)

Sunbathing in Seattle is not a common activity for most locals, but whenever the sun comes out, many sun-loving residents in the floating homes community will be out soaking up the sunshine. In this 1970 photograph, a couple relaxes on the dock while children swim nearby. (Courtesy of Linda Knight.)

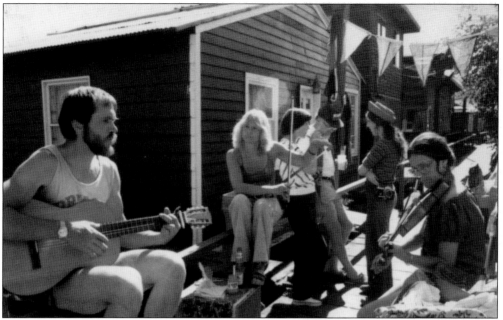

Another community pastime on the Log Foundation docks was playing in a band. In this case a group of friends came together to provide entertainment during a rummage sale in 1980. Band members are, from left to right, Tom Haslett on the guitar, Jann McFarland on the saw, and Martha Rubicam on the fiddle. (Courtesy of Jann McFarland.)

In this 1978 photograph, Sid and Jann McFarland pose for their own version of Grant Wood's *American Gothic* painting in front of their floating home on the Log Foundation docks. Jann is a longtime resident of the community and also serves as the office manager for the FHA, which gives her a unique knowledge of the community history. (Courtesy of Jann McFarland.)

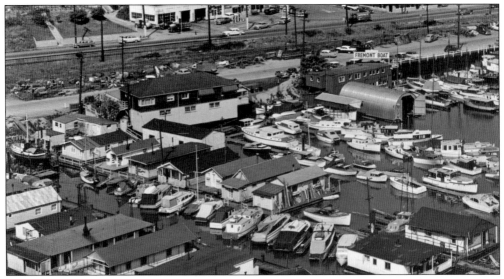

Lee's Moorings, located in the Fremont neighborhood, is one of only two floating home moorages on the north shores of Lake Union. The other is the University dock located on the northern side of Portage Bay, where it leases moorage rights from the University of Washington. This aerial photograph from 1954 shows the houseboats of Lee's Moorings in the foreground amidst private and commercial marinas. (Courtesy of Sylvia Hubbert.)

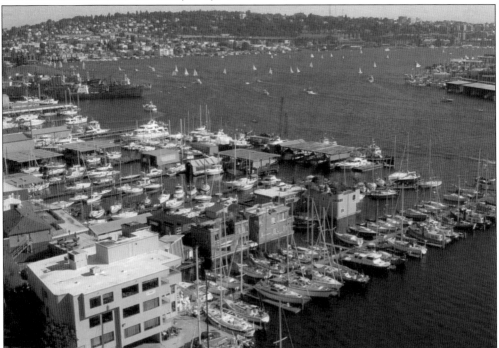

This 2003 photograph overlooking Lee's Moorings shows how much the area has been developed in the past 50 years. Buildings have been added along the shore, utilities have been moved below the dock, and most of the older floating homes have been replaced with two-story houses. The railroad tracks visible in the 1954 aerial are now the location of the Burke Gilman Trail. (Courtesy of Sylvia Hubbert.)

Starting in the 1930s, Ed Lee and his
wife, Alice, owned a shoreline property
in Fremont that was initially used as
a dry dock for boat repairs as well as a
marina before becoming a moorage for
houseboats. The moorage was converted
to condo ownership after the Lees had
both passed away, but many of the
residents lived there while the Lees
were still around and have remained
close friends over the years. This pair of
photographs from 1937 capture Ed and
Alice fashionably dressed and standing out
on the docks across from the houseboats.
(Both, courtesy of Sylvia Hubbert.)

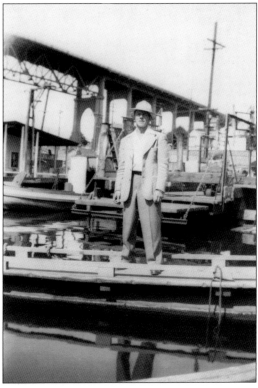

Ed Lee's office for managing the business related to the dry dock, marina, and moorage was located in a floating structure at the shore end of the dock. Ed and Alice also lived in a houseboat near the shore, partly because Alice had a fear of the open water. (Courtesy of Sylvia Hubbert.)

The west side of the dock continued to be operated as a dry dock by Ed Lee long after houseboats filled the east side of the dock. This photograph was taken in 1971 and documents the balance of commercial and residential use that is commonly found on the urban waterways of Seattle. (Courtesy of Sylvia Hubbert.)

Ed Lee set aside a small barge for the dock residents to use for gatherings and recreation. Here, residents enjoy a Fourth of July celebration in 1982. Pictured from left to right are Alice and Ed Lee, Evert Sundersrom, Edith Fairhall, Dick ?, Sylvia Hubbert, Jeff Acorn, Jim and Nancy Bernal, Herb and Betty Sigmund, and Dorothy ?. (Courtesy of Sylvia Hubbert.)

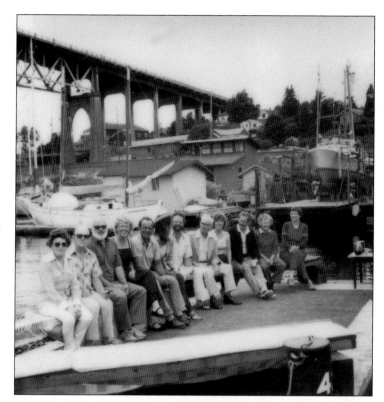

Christmas has always been a time shared among neighbors on the Lee's Moorings dock. Alice Lee would make everyone cookies each year, and someone would host a party. In 1990, Alice (seated, center) came back to visit for the Christmas party with many of her old renters. (Courtesy of Sylvia Hubbert.)

This floating home on Portage Bay was reconstructed in 1996. The original home was built around 1918 and was not worth the work necessary to repair it. Although owners Marilyn Robertson and Jim Weyand decided to double their living space to 1,200 square feet by adding a second floor during the rebuild, they worked closely with architect Gene Morris to re-create the character and charm of the older home. A front porch and two second-floor balconies preserve the connection with the dock and neighboring residents. Windows all around the house allow for views, natural ventilation, and engagement with the surrounding community. (Both, courtesy of Marilyn Robertson and Jim Weyand.)

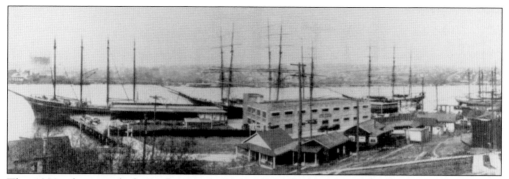

This 1920s photograph shows the Wards Cove fish packing company buildings once located on the eastern shore of Lake Union. In 2002, the company closed and the family decided to redevelop the waterfront property as a mixed-use development, including 12 new moorages for floating homes. On the market since 2009, these sites are advertised as the "last new floating home slips ever to be offered in Seattle." (Courtesy of the Wards Cove Company.)

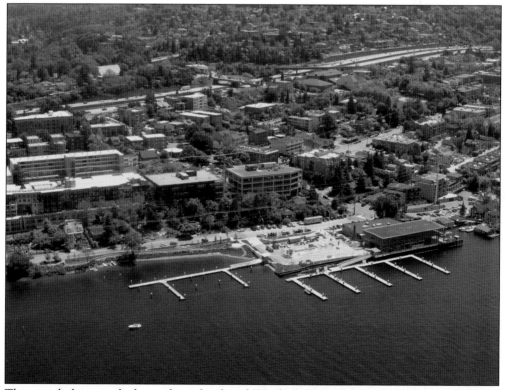

This aerial photograph shows the redeveloped Wards Cove property on Lake Union. Most of the old warehouses have been removed to open up views and access on the site, although one was adapted for reuse as office space by the Seattle architecture firm atelierjones. A public park, townhomes, private parking, and marina space for super yachts share the site with the floating homes moorage. (Courtesy of the Wards Cove Company.)

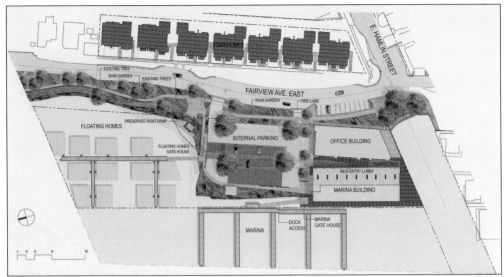

This plan completed by the Seattle architecture firm atelierjones for the Wards Cove Company shows many of the strategies used to enhance the site. With the architects' help, Wards Cove developed design guidelines for new residents—offered in the form of suggestions—as an attempt to add character and foster community among dock residents and to avoid the design of boxlike floating homes seen on some newer docks. (Courtesy of atelierjones.)

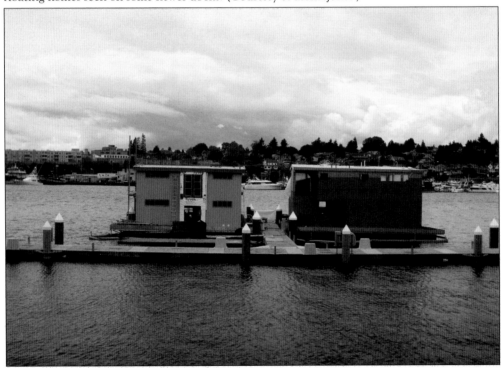

As only a few of the floating homes have been built at the Wards Cove moorages as of 2011, it remains to be seen what the character of this new dock will be. Whether or not prescribed architectural sensitivity can create a sense of community and character or if these truly are the "last new floating home slips" in Seattle remains to be seen. (Author's collection.)

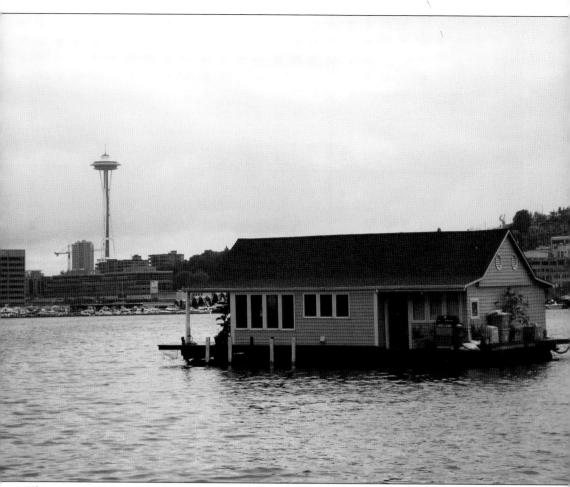

This image of a floating home anchored briefly in the middle of Lake Union, with the Seattle Space Needle visible beyond, is a reminder that the floating homes community does not exist in isolation from the city of Seattle. The community shares with its city the legacy of an industrial, working-class past transformed through community engagement, environmental efforts, land use battles, and local investment. Both have become more modern, expensive, and gentrified versions of their former selves, yet both strive to maintain a connection to the past and preserve some of their original charm. The viability of the floating homes community as an urban neighborhood located in the middle of the city of Seattle comes from a combination of factors, including distinct architectural character, density of residences, strong ties between residents, and a collective sense of involvement in the community. (Courtesy of Leslie Silverman.)

EPILOGUE

The history of the floating homes in Seattle is far from over. While the floating homes seem to have secured a relatively stable legal and social standing in the city, threats to the stability of the community have resurfaced in the past. Although the existence of the community may be more certain than it has been, the engagement of the community, its lively history, and architectural character that have made it so unique are threatened by recent changes. If the moorages at Wards Cove truly are the last floating home slips in Seattle, then increasing home values, boxlike architecture, and exclusive ownership may replace the modest, eclectic community forever. In terms of preserving a diverse community, distinct architectural identity, and remnants of the colorful past of the floating homes, the challenges may be just beginning as the community continues to gentrify and modernize along with the rest of Seattle.

This book shares the background of historical individuals, events, and challenges that have made Seattle floating homes into a unique urban community. An exhibit on the floating homes community at the Museum of History & Industry in 2013 records the more contemporary history of the community, told in part by the residents themselves through oral histories and interviews. Although the floating homes community will continue to evolve, hopefully the past will be celebrated and the bonds of community among residents and to the city of Seattle will be strengthened as time goes on.

BIBLIOGRAPHY

Dennis, Ben and Betsy Case. *Houseboat: Reflections of North America's floating homes . . . history, architecture, and lifestyles.* Seattle, WA: Smugglers Cove Publishing, 1977.

Droker, Howard. *Seattle's Unsinkable Houseboats: An Illustrated History.* Seattle, WA: Watermark Press, 1977.

Flanagan, Barbara, and photography by Andrew Garn. *The Houseboat Book.* New York, NY: Rizzoli, 2003.

FHA Newsletter. Seattle, WA: Floating Homes Association, 1962–2011.

Hidaka, Pamela. *A Design Vocabulary for Floating Home Communities.* Seattle, WA: University of Washington Press, 1989.

Laturnus, Ted. *Floating Homes: A Houseboat Handbook.* Madeira Park, British Columbia, Canada: Harbour Publishing Co. Ltd., 1986.

Steinbrueck, Victor. *Seattle CityScape No. 2.* Seattle, WA: University of Washington Press, 1973.

DISCOVER THOUSANDS OF LOCAL HISTORY BOOKS FEATURING MILLIONS OF VINTAGE IMAGES

Arcadia Publishing, the leading local history publisher in the United States, is committed to making history accessible and meaningful through publishing books that celebrate and preserve the heritage of America's people and places.

Find more books like this at
www.arcadiapublishing.com

Search for your hometown history, your old stomping grounds, and even your favorite sports team.